MINNESOTA TWINS
Baseball

HARDBALL HISTORY ON THE PRAIRIE

STEW THORNLEY

THE
History
PRESS

Published by The History Press
Charleston, SC 29403
www.historypress.net

First published 2014

Manufactured in the United States

ISBN 978.1.62619.381.9

Library of Congress CIP data applied for.

To my mom, dad and Grandma Hubbard, who took my brother and me to our first game on July 19, 1962 (when Jim Kaat pitched a three-hit shutout, Bob Allison hit two home runs and Vic Power stole home).

CONTENTS

Acknowledgements 7

1. Minnesota Makes It to the Majors 9
2. The First Decade 25
3. Fighting for Relevance 49
4. Inside Baseball 67
5. Championship Runs 81
6. Sliding into the Next Century 92
7. Central Champs 100
8. Outdoors Again 115

Appendix: Twins Leaders and Honors 121
Sources 125
About the Author 127

ACKNOWLEDGEMENTS

Thanks to Dan Levitt and Joel Rippel for their help in providing information about the Twins, as well as to Jeanne Anderson of the St. Louis Park Historical Society.

As always, the Minnesota Twins were supportive, especially Dustin Morse, Mitch Hestad, Mike Kennedy, Dave St. Peter and Clyde Doepner.

I appreciate the willingness of many people connected with Minnesota baseball to be interviewed and share their memories: Bob Allison, Earl Battey, Bert Blyleven, George Brophy, Rod Carew, Herb Carneal, Dean Chance, Ray Christensen, Ron Coomer, Dave Frishberg, Paul Giel, Angelo Giuliani, Dave Goltz, Glenn Gostick, Jim "Mudcat" Grant, Halsey Hall, Joe Hauser, Monte Irvin, Jerry Kindall, Tim Laudner, Gene Mauch, Willie Mays, Tom Mee, Marvin Miller, Jack Morris, Tony Oliva, Frank Quilici, Howie Schultz, Ray Scott, Roy Smalley, Herb Stein, Terry Steinbach, George Thomas, Sandy Valdespino, Zoilo Versalles, Charley Walters, Ted Williams, Al Worthington and Don Zimmer.

CHAPTER 1

MINNESOTA MAKES IT
TO THE MAJORS

MINNESOTA BEFORE THE TWINS

From the milling of lumber and flour spawned by the power of the Mississippi River to the diversified industries of food, finance, computers and transportation, Minnesota has produced a "vigorous business community and one that plays a role in the overall quality of life, in which Minnesota is ranked near the top," according to Don W. Larson in his 1979 book on Minnesota business, *Land of the Giants*.

The place and setting of Minnesota left it insulated from the large cities to the east. Yet amenities have always abounded. Arts, theater, parks, education and sports have contributed to the quality of life and the state's high ranking.

Side by side, mostly separated by a great river, are Minneapolis and St. Paul. They have been known as the Dual Cities, the Twin Cities and, to some in the region, just The Cities. Although they grew up together, the cities are distinct and have often been rivals, sometimes intensely but with a softening over time.

The arrival of a major-league baseball team that represented all of Minnesota brought sports fans together, and the edge that marked the divisions between the cities has dulled.

Minnesota did have a baseball team represented in the major leagues in the nineteenth century, but its tenure was as brief as the story unremarkable. In 1884, St. Paul played nine games, all on the road, in an organization

named the Union Association, currently recognized as a major league but with a history as forgotten as the many teams that came and went in the league's only season.

That year, 1884, marked the first in which Minnesota had teams in a fully professional baseball league. The Northwestern League had Minneapolis, St. Paul and Stillwater on its roster of clubs and later in the season had a team in Winona. Stillwater stood out because of Bud Fowler, an infielder and pitcher who has been recognized as the first black player in organized baseball. Fowler was among the best of a bad lot as Stillwater lost its first sixteen games of the season.

Minneapolis, aiming for higher status, went beyond its boundaries for players. In doing so, it let some good players get away. Not courted by their hometown team, Elmer Foster, Billy O'Brien and Charley Ganzel didn't have to go far to find a welcome, being snapped up by the neighbors to the east. The baseball rivalry between Minneapolis and St. Paul was on.

In the early 1900s, the Millers and Saints, as the teams had become known, joined a new minor league, the American Association. At this time, all of major-league baseball was to the east. Even western road trips took major-league teams only as far as Chicago and St. Louis, with cities such as Detroit, Cincinnati, Cleveland and Pittsburgh considered part of the West.

Midwestern cities such as Minneapolis, St. Paul and Kansas City knew their role—to provide quality baseball entertainment to their residents at a level just beneath the majors. The Minneapolis Millers and St. Paul Saints were among the best. In their fifty-nine seasons in the American Association, the Millers and Saints had the highest overall winning percentages and shared the record for the most pennants won.

On occasion, fans got to see the big-name players. Babe Ruth and Dizzy Dean came through as part of exhibition games or barnstorming tours. Some of the players on the Saints and Millers had notable careers in the majors, either before or after playing in Minnesota. Ted Williams, Duke Snider, Willie Mays, Roy Campanella, Rube Waddell, Lefty Gomez and Ray Dandridge are among the players in the Baseball Hall of Fame who once were Millers or Saints. In addition, Lou Brock and Gaylord Perry played for another minor-league team in Minnesota, the St. Cloud Rox.

However, the names most familiar to local fans were those who stayed and performed at high levels for a number of years. Joe Hauser spent five seasons in the 1930s in Minneapolis, hitting more than two hundred home runs during that time. A left-handed hitter, in 1933, Hauser set a then-

professional record with sixty-nine home runs, fifty of them at Nicollet Park, known for its short distance to the right-field fence.

Lexington Park in St. Paul wasn't as cozy, but it was equally beloved, as was Eric "The Red" Tipton, who joined the Saints in 1946 and had at least one hundred runs batted in (RBIs) in each of his first four seasons with the team.

For many years, minor-league fans could count on seeing the same players year after year. Minor-league teams were originally run as independent operations for the benefit of their owners and fans, not as a steppingstone to develop players for the major leagues. By the 1940s, though, the growing farm system trend overtook the Saints and Millers, who became farm teams for the Brooklyn Dodgers and New York Giants, respectively. It didn't take long for fans to notice the effect.

Players came and went quickly at the whim or need of the major-league teams. The subservient status of the minors hit a new level of clarity in 1951. The news from spring training for the Millers was about an exciting center fielder, Willie Mays. Fans were eager to see the new star, especially after how he performed on the road in the opening weeks of the regular

BASEBALL IN THE TWIN CITIES is connected with iconic names. Charles Schulz, creator of *Peanuts*, grew up in St. Paul and was an avid fan. His love of baseball carried into the comic strip, featuring the forlorn team led by Charlie Brown. In 1974, Schulz worked the 1938 Saints along with the team's star that year, Ollie Bejma, one of his favorite players, into a *Peanuts* strip.

Another St. Paul native, Dave Frishberg, was a fan of the Saints in the 1940s. Frishberg became a renowned jazz musician and songwriter with many baseball compositions, notably Van Lingle Mungo, a bossa nova with the lyrics consisting of baseball names from his youth. Frishberg remembers Van Lingle Mungo as a pitcher with the Millers and, in the lyrics, includes Eddie Basinski, whom Frishberg saw play with the Saints.

Wheaties cereal, a product of Minneapolis-based General Mills, is known as the "Breakfast of Champions." That slogan first appeared on a signboard at Nicollet Park in 1933, when General Mills contracted for Wheaties sponsorship of radio broadcasts of Millers games.

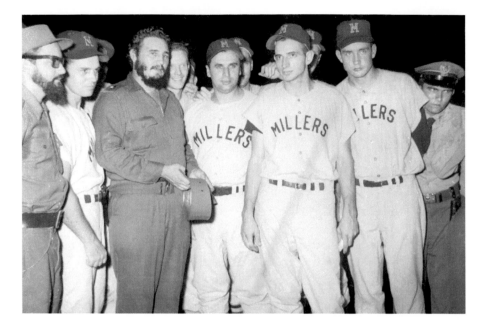

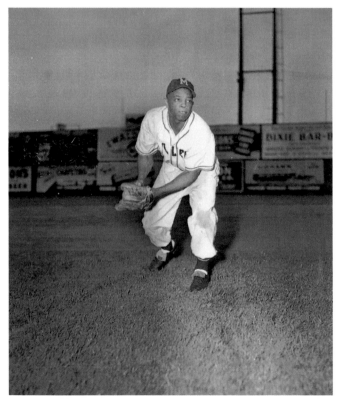

Above: The Minneapolis Millers played in the 1959 Junior World Series against the Havana Sugar Kings and had the chance to meet Fidel Castro. Millers manager Gene Mauch is second to left in the photo, with Castro to his left. *Author's collection.*

Left: Willie Mays had a short but spectacular stay in Minneapolis in the spring of 1951. *Author's collection.*

NEW YORK

Giants NATIONAL EXHIBITION COMPANY

THE BASEBALL FANS OF MINNEAPOLIS!

We feel that the Minneapolis baseball fans, who have so enthusiastically supported the Minneapolis club, are entitled to an explanation for the player deal that on Friday transferred outfielder Willie Mays from the Millers to the New York Giants.

We appreciate his worth to the Millers, but in all fairness Mays himself must be a factor in these considerations. Merit must be recognized. On the record of performance since the American Association season started, Mays is entitled to his promotion, and the chance to prove that he can play major league baseball. It would be most unfair to deprive him of the opportunity he earned with his play.

We honestly admit too, that this player's exceptional talents are the exact answer to the Giants' most critical need.

Please be assured that the New York Giants will continue in our efforts to provide Minneapolis with a winning team. The Millers won the pennant in 1950, and another in 1951 is our objective.

Sincerely yours,

HORACE C. STONEHAM, President

The New York Giants took out an ad in the May 27, 1951 *Minneapolis Tribune* after calling up Mays. *Author's collection.*

season. However, those waiting for the weather to warm up before getting out to Nicollet Park missed their chance. On May 25, the New York Giants called Mays up to the majors after only thirty-five games with the Millers. Mays had been spectacular, too good to stay in the minors, but it was a shock to the fans. The Giants bought a full-page ad in the *Minneapolis Tribune* explaining why they needed Mays. The fans and press weren't placated and realized that the plucking by the parent team was more than just about Mays. It was a signal that local baseball, as they had known it, had changed.

Two questions came up. Was minor-league baseball enough for the Twin Cities anymore? More significantly, could they do better?

THE TWINS BEFORE MINNESOTA

Washington, D.C., has a long history in professional baseball. The city had several major-league teams in the nineteenth century, but its franchise was one of four dropped by the National League when it went from twelve to eight teams after the 1899 season.

Two years later, when the American League took on major-league status, Washington became a charter member. For most of its time in the capital, the team was officially named the Nationals but commonly referred to as the Senators.

Most of the team's time in Washington was moribund, spawning the crack "Washington—first in war, first in peace, and last in the American League."

However, the Senators had a few high points, and two names in Washington baseball history stand out.

Walter Johnson joined the team in 1907 and within a few years was regarded as the best pitcher in the game, possibly of all time. Considered to have the best fastball in baseball, Johnson struck out more than 3,500 batters in his career. Several pitchers later surpassed his strikeout record, but Johnson achieved his total mainly during the Deadball Era, a period that preceded the big swingers.

Walter Johnson. *Minnesota Twins.*

In 1912, Johnson was credited with thirty-three pitching victories and helped the Senators finish second, the first time the team placed higher than sixth in the eight-team American League.

Also leading the team to its first winning record was Clark Griffith, in his first year as Washington manager. Griffith had been an outstanding pitcher and combined managing with playing in 1901. While managing the Senators, Griffith also began acquiring an ownership interest and became the club's president in 1920.

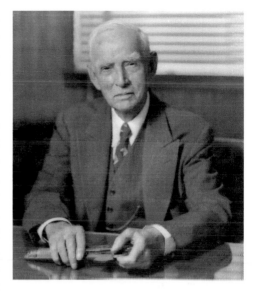

Clark Griffith. *Minnesota Twins.*

Around this time Griffith took custody of two children of his wife's brother, James Robertson, who lived in Montreal and had health as well as money problems. Calvin and Thelma Robertson moved to Washington and, although never formally adopted, took the Griffith name.

Clark Griffith ran the Senators as a family operation, and Calvin and Thelma eventually worked for the team along with their brothers and sisters who had stayed with James Robertson. As a twelve-year-old, Calvin Griffith was a batboy for the Senators in 1924, the year that was a high point of the team's years in Washington.

The New York Yankees, in the early years of a decades-long dynasty and champions of the American League the past three seasons, were favorites again to win the pennant. However, the Senators, who had finished fourth the year before, worked their way into a race with the Yankees of Babe Ruth and the Detroit Tigers of Ty Cobb. Washington moved into the lead in late June, stayed close through the heart of the summer and took the lead again in late August, remaining in first or tied for first the rest of the way and finishing two games ahead of New York.

The Senators were led by a veteran and guided by a relative youngster. Walter Johnson, in his eighteenth season, led the American League with twenty-three wins. Bucky Harris, a twenty-seven-year-old second baseman, also was in his first year of managing the team and acquired the moniker "Boy Manager."

Washington's opponent in the World Series, the New York Giants, had won their fourth straight National League pennant. Those pulling for the Senators included President Calvin Coolidge, who attended the World Series games in the capital. Many fans were excited that the thirty-six-year-old Johnson, who had hinted at retiring at the end of his season, finally had made it to the World Series. Washington fans were even advised to not be "too vigorous" in shaking Johnson's hand in order to protect his right arm.

But Johnson was the losing pitcher in the twelve-inning opener as well as the fifth game, and it looked like he wouldn't get the World Series win that so many were hoping for.

The series went to a decisive seventh game, and though Johnson didn't start, he entered the game after the Senators scored two runs on Harris's bad-hop single to tie the score in the last of the eighth. The Big Train, as Johnson was known, again had a shot at a World Series win, one that would give his team the championship.

Both teams threatened in the ninth but didn't score, and the game went into extra innings.

With one out in the last of the twelfth inning, Muddy Ruel lifted a pop fly behind the plate. Giants catcher Hank Gowdy had trouble with the ball from the start. He circled under it and then flung his mask away as he seemed to figure out the spot it would drop. However, at the last instant, Gowdy had to lunge to his right. He might have still made the catch if he hadn't stumbled over his mask. Nearly falling to one knee, Gowdy dropped the ball.

The error gave another chance to Ruel, who ripped a pitch inside third base and into left field for a double. One batter later, with Ruel still on second, Earl McNeely hit a sharp grounder toward Freddie Lindstrom at third.

News reports vary on exactly how the ball ended up past Lindstrom, allowing the winning run to score. Most retrospective accounts describe it as a similar play to Harris's hit in the eighth, which took a bad hop over Lindstrom's head. Stories from the time, however, provided other details, some of them contradictory.

However it got by, through or over Lindstrom, the ball made it out to left fielder Irish Meusel, who held the ball, declining to make even the gesture of an attempt to head off Ruel with a throw home.

The Senators had their championship, Walter Johnson had his victory and the citizens of Washington rejoiced on Pennsylvania Avenue and elsewhere through the night.

Another celebration came in 1925, although this time it was for only a league championship. Walter Johnson, who didn't retire, won two games in

the World Series against Pittsburgh, but in the seventh and final game, he couldn't hold a four-run lead and lost to the Pirates.

As Clark Griffith worked his family members into the Senators organization, some worked their way into the family. Shortstop Joe Cronin came to Washington in 1928 and soon began courting Mildred Robertson, who was Griffith's secretary and also his niece.

Cronin became player-manager in 1933 as the Senators won ninety-nine games to win the pennant before losing to the Giants in the World Series.

In 1954, the Senators signed a young slugger from Idaho, Harmon Killebrew, who was recommended by Idaho senator Herman Welker. Welker's law partner, Vernon Daniel, sent this telegram to Senators farm director Ossie Bluege. *Author's collection.*

Cronin and Robertson married near the end of the 1934 season. While they were on their honeymoon, Cronin got the word that he had been traded to the Boston Red Sox. The deal included $250,000 from the Red Sox, and an indication of how badly Griffith needed the money was that he was willing to trade a family member. (The $250,000, a huge figure during the Depression, marked the highest price paid for a player up to that time.)

During World War II, all teams cut expenses, the Senators in particular. Griffith scaled back on his scouts and relied heavily on one ivory hunter, Joe Cambria. Cambria focused on Latin America, finding a largely untapped pool of talent that also was inexpensive. The Senators' connection to the Caribbean remained strong, particularly in Cuba and especially after skin color no longer disqualified a player from organized baseball, a trend that continued after the team moved to Minnesota.

Clark Griffith died in 1955, and Calvin took over as president. The Senators were as dismal as ever, and the usual low finish in the standings was commensurate with the small number of fans who attended games. As other major-league teams were relocating, Griffith explored a new home for the Senators.

By this time, the Senators were finally building a strong farm system, which would produce better players. Unfortunately for fans in Washington, by the time this happened, the team was no longer there.

Bringing a Team to Minnesota

By the midpoint of the twentieth century, the sixteen teams in the major leagues had occupied the same cities for nearly fifty years. All were playing in stadiums built during the classic-ballpark period, which had started in 1909. Beyond the aging of the structures was their location, in congested areas better served by public transportation than automobiles. Postwar suburban flight was leaving the locales in decaying areas.

Half the cities in the majors had at least two teams, and it was becoming clear in some that a team was expendable. The lure of other cities, especially those with a stadium outside of the city core and surrounded by parking lots, was strong. Just prior to the 1953 season, the Boston Braves, a National League team sharing the demand for baseball with the American League Red Sox, made the move. The Braves' top farm team in the American Association, the Milwaukee Brewers, was about to open a stadium to the

west of the downtown area. Instead, the new ballpark became the domain of the major leagues as the Braves moved in.

The breaking of a half-century logjam gave hope to other cities. The Minneapolis Chamber of Commerce formed a committee to lure a major-league team of its own to the area. By the end of 1953, it was clear that another might be in the mood to move. The St. Louis Browns shared a city and a stadium with the Cardinals, who had become the main team in the city, and the lesser Browns were looking for a new home.

Minneapolis made a play for the Browns, but a sticking point was the lack of a suitable stadium in the Twin Cities. The local group offered to build a new ballpark and expand Parade Stadium, on the edge of downtown Minneapolis, in the interim. However, another city, Baltimore, had recently rebuilt a stadium to major-league caliber, and the Browns moved there instead.

It had become apparent that the Twin Cities needed a new stadium to land a team. In addition, the two minor-league teams, the Millers and Saints, were in need of new stadiums to replace aging Nicollet Park in Minneapolis and Lexington Park in St. Paul. Perhaps one of the new parks could eventually serve a major-league team.

By chance, such a ballpark had nearly materialized a few years before. The New York Giants, after purchasing the Minneapolis Millers, explored sites on the edges of the city and into the suburbs. In 1948, the Giants settled on a location a few miles west of downtown by Theodore Wirth Park, but the location didn't go over well with the residents in the area. The Giants then purchased land on the southwest quadrant of Wayzata Boulevard (now Interstate 394) and the Belt Line (now Highway 100) in St. Louis Park.

Residents, business and civic organizations were more enthusiastic than those around the Wirth site, and the village council approved a zoning change to allow for a ballpark, provided that construction began within five years. The stipulation on timing seemed unnecessary since the Giants indicated they were prepared to build quickly, with a projected completion in time for the 1950 season. Plans called for an eighteen-thousand-seat stadium with plenty of parking. The stadium was to have a horseshoe shape similar to the Polo Grounds, where the Giants played in New York, to allow a suitable seating configuration for both football and baseball.

For some reason, the bulldozers and graders never showed up. News about the stadium continued, but no earth was moved, no piling driven and no concrete poured. An item in the *St. Louis Park Dispatch* in February 1950 noted that Lionel Levy, "a well known builder of parks, stadiums and arenas…and

for many years has had a role in almost every large sports arena built," had come from New York to inspect the property. Nothing more appeared in the paper regarding the ballpark.

The Giants apparently got cold feet regarding construction, perhaps hampered by material shortages with the outbreak of the Korean conflict, and finally gave up on the project when another stadium in the area emerged.

A neighboring restaurant had sold the property to the Millers (and, by extension, the Giants) at a reduced price because of the potential business it would generate. When a ballpark wasn't built, the restaurant unsuccessfully sued the team to get the land back. The Giants held on to the property for more than twenty years, and the lot eventually was called Candlestick Park, the same name of the stadium the Giants built on Candlestick Point in San Francisco after moving west.

With an itch but not a stadium for a major-league team, Minneapolis business leaders looked to address both.

Amy Klobuchar, for her senior thesis at Yale University in 1982, wrote of an "active role by the Minneapolis private sector in helping government meet community needs," as well as a "trusting relationship between business and government." She cited an observation of Don Fraser, then mayor of Minneapolis, that "the most important things in this town have happened at the initiative of the business community, not of government." Fraser was speaking of projects such as the Nicollet Mall and the skyway system, connecting downtown buildings, but the sentiments extended decades into the past.

In 1954, the City of Minneapolis approved the issuance of revenue bonds to finance a stadium. St. Paul declined to participate, even though the proposed site was in another suburb, this one to the south, rather than in Minneapolis itself and issued its own bonds for a stadium for the St. Paul Saints and, it was hoped, a major-league team.

A group of business and other civic-minded people dubbed the Minneapolis Minute Men led the drive to sell bonds for the suburban stadium and topped its goal by more than 50 percent. Charles Johnson, sports editor of the *Minneapolis Star and Tribune*, wrote, "A job has been done that many people said couldn't be done. This is the greatest display of civic spirit we've ever seen. It's a victory of civic pride and baseball."

With the financing in place, ground was broken in a cornfield in the village of Bloomington in mid-1955. By the following spring, a triple-decked structure, eventually to be known as Metropolitan Stadium, was ready. The minor-league Millers played there first, although the aspirations for a long-term tenant were higher than that.

New York Giants owner Horace Stoneham attended the first Millers game played at the new stadium in 1956, proclaimed it the best minor-league stadium in the country and added, "There are not over two in the majors that are better." Stoneham's approval created hope in Minnesota that the Giants might move there from New York.

Along with Brooklyn Dodgers owner Walter O'Malley, Stoneham wanted a new stadium in New York, and neither was happy about the options his city was offering. Stoneham had been quizzed as early as 1954, even before the new stadium was on the drawing board, about moving to Minnesota and replied that he had no intention of doing so. By 1956, however, Stoneham was changing his tune, and with the opening of Met Stadium, others were picking up on the possibility. An article in *Sports Illustrated* noted, "There are high hopes now in Minneapolis that the bright new stadium will help the city to graduate from a Giant farm town to the Giants' home."

The excitement in Minnesota might have been even greater had anyone been privy at the time to an internal memo written by O'Malley in March 1957 in which he revealed, "Mr. Stoneham made up his mind sometime ago to move his franchise from New York to Minneapolis. He told me that his decision was quite independent of anything Brooklyn might do. He is prepared to move for the 1958 season."

However, Stoneham stayed tied to O'Malley, who was looking west all the way across the continent to Los Angeles. O'Malley suggested that Stoneham explore San Francisco instead of Minnesota, allowing the rivalry between the teams to continue in California and also making travel to the West Coast more efficient for visiting teams. By the time Stoneham announced he would be leaving New York, in July 1957, his preference for San Francisco was clear; he said he'd be willing to listen if the Twin Cities could make a better proposition, although this was likely no more than a gesture to placate fans where he still had a minor-league team. In the end, the Giants and Dodgers both moved across the country, leaving the local committees looking for another team.

Soon after Stoneham made it clear that he was not moving to the Twin Cities, Laurie Cavanaugh of the *Minneapolis Star and Tribune* wrote a treatise pointing out the advantages of the area for a major-league team. Population and projected growth, literacy, income and wealth, the rich heritage of the game in the state (amateur baseball was noted, but a number of significant all-black teams that played prior to the integration of organized baseball wasn't) and the absence of pari-mutuel betting were among the selling points Cavanaugh promoted in his pitch for a team to come to Minnesota.

The commission that operated Met Stadium scheduled exhibition games with major-league teams as a way to show off the new ballpark, provide a popular attraction for fans and demonstrate that the area would support major-league baseball. Crowds for the games often exceeded twenty thousand fans.

No one within baseball seemed to disagree about the potential of the Twin Cities, but would the purging of multi-team cities continue? After the Boston Braves, St. Louis Browns, Philadelphia Athletics (to Kansas City in 1955), Brooklyn Dodgers and New York Giants cleared out, only Chicago remained with more than one team, and it was unlikely that either the Cubs or White Sox would move.

The Cleveland Indians were considering a move to Minnesota, and Cincinnati Redlegs owner Powel Crosley was talking of leaving, possibly for New York after the National League pulled out of that city. Washington was the only other team showing any inclination to move. Reports in October 1957 indicated that Senators president Calvin Griffith was negotiating to move to Minnesota, although Griffith denied them.

The following July, Griffith asked for a special meeting of the American League and was poised to seek permission to move the Senators, with Minnesota among four sites he was considering. However, Congress was holding hearings on baseball's exemption from federal antitrust laws. With baseball owners nervous about a backlash from Congress if they abandoned the national capital, Griffith postponed his request on the eve of the meeting and issued the following statement: "I'm advising the American League tomorrow that the Washington baseball club will not ask for approval of the move to Minneapolis or any other city."

The quest for a major-league team was becoming more than an issue of civic pride and the bruises to it when the rejections came. The minor-league Millers weren't producing enough revenue to cover the interest on the bonds that had been issued for Met Stadium. Some bondholders agreed to defer their payments, creating a reprieve that kept the facility from falling into default. Minneapolis was also called on to help refinance the debt. The city came through, although in ensuing years, Minneapolis government and business leaders became more reluctant to foot the bill for a stadium outside its borders.

Minnesota wanted and needed a major-league team, but after a five-year flurry of relocations, baseball seemed settled on the teams it had in the cities in which they were.

The other option was more teams. The majors had been at sixteen teams since the start of the century, and it appeared the league could handle more.

New York, in particular, had room for another team, and it was this void in the country's largest city that prompted the creation of a new organization, the Continental League. In 1959, the Continental League sought major-league status and looked to put teams in a number of cities in the United States and Canada, including Minneapolis-St. Paul.

As this was happening, another group with similar frustrations formed to challenge the National Football League (NFL). In August 1959, the Twin Cities were awarded a franchise in the new American Football League (AFL). That fall, as the AFL was holding its first draft in Minneapolis, news leaked that Minneapolis-St. Paul was getting, and accepting, a bid from the NFL. Two months later, it became official that the NFL was expanding and that Minnesota would join in 1961. Executives in the AFL called the NFL expansion an "act of war" and decided to carry on even though the NFL was moving into cities where the new league planned to operate. (The NFL was also expanding into Dallas, where the AFL had placed a team.)

On the other hand, the Continental League faded away after baseball decided to add two teams to each of its leagues. The Continental League

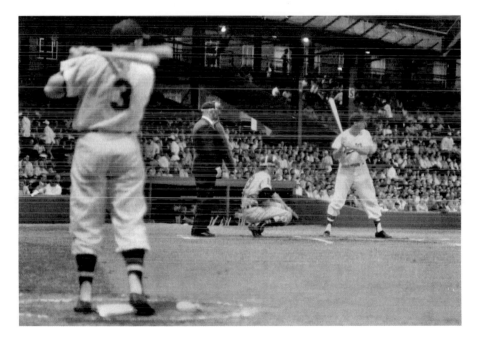

Bob Allison (at bat) and Harmon Killebrew (on deck) were two of the Washington Senators' young stars. In 1959, Killebrew hit forty-two home runs, and Allison was the American League's Rookie of the Year. *Minnesota Twins.*

achieved its goal of getting the major leagues to expand, although some in the organization were still unhappy that cities such as Denver and Toronto, slated for inclusion in the Continental League, did not get a team at that time.

The sports scene changed greatly in Minnesota in 1960. The year started with a National Football League team. Mid-year brought the end of the Minneapolis Lakers of the National Basketball Association as that franchise moved to Los Angeles. By the second half of the year, it was becoming apparent that the big prize might finally come to the state.

Expansion of major-league baseball seemed likely to reach the Twin Cities. The National League acted first, announcing the addition of teams in New York and Houston for 1962. The American League owners met a week and a half later, on October 26, 1960, and agreed to expand but with a twist.

New teams were announced for Los Angeles and Washington for the 1961 season. With an expansion franchise in Washington, the owners finally gave Calvin Griffith permission to move to Minnesota. The Senators were still dismal but had reason for optimism with a roster that included talented young players. However, they would be operating in a new place. Griffith may have considered keeping the "Senators" nickname, but when the owners of the new Washington franchise insisted on keeping the name, he announced in November 1960 that the team would be the Minnesota Twins.

In explaining the decision to use the state as the geographic designation (something the new NFL team, the Vikings, had done two months earlier), Griffith said, "We want our new baseball enterprise to be for everyone in Minnesota and the Upper Midwest."

CHAPTER 2

THE FIRST DECADE

BUILDING TO THE TOP

Entering 1961, the Minnesota sports landscape no longer had professional basketball. The National Football League was coming later in the year, and college football was big. The University of Minnesota Gophers opened 1961 by playing in their first Rose Bowl. The Gophers lost, but the polls were already done, and Minnesota had been voted national champions.

The biggest buzz, though, was for the Minnesota Twins. Having a baseball team in the highest level of play was still the biggest prize for metropolitan areas that wanted to be considered major-league.

Would the incoming Twins be good after years of being bad in Washington? Initially, the question was secondary. Regardless of the strength of the team or its spot in the standings, the biggest bonus was that Minnesota was included in the roster of American League teams. It meant the stars of the league—Mickey Mantle, Al Kaline, Brooks Robinson, Whitey Ford, Luis Aparicio, Jim Bunning, Rocky Colavito—would be performing at Met Stadium. In addition, the incoming Twins had stars of their own: Earl Battey, Bob Allison, Jim Lemon, Harmon Killebrew and pitchers Camilo Pascual, Jack Kralick and Jim Kaat.

The pitcher tabbed to start the opener was Pedro Ramos, a sidearming right-hander from Cuba who sometimes talked of returning home to fight against Fidel Castro. Ramos had led the American League in losses the

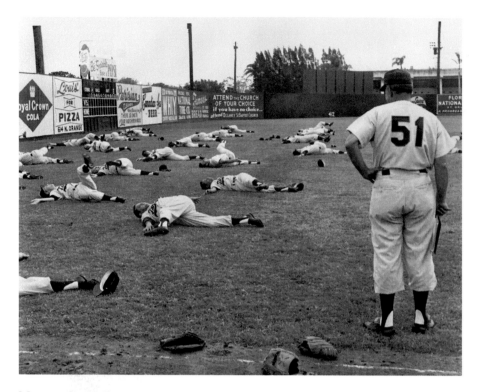

Manager Cookie Lavagetto oversees spring training in 1961. *Minnesota Twins.*

previous three seasons and would do so again in 1961, although his record was partly a product of the poor teams he played for.

Manager Cookie Lavagetto decided that Ramos's sinking fastball might be the antidote to the New York Yankees. Lavagetto picked well, at least for the opener. Ramos shut out the Yankees and also had a two-run single off Whitey Ford. Allison and Reno Bertoia homered as the Minnesota Twins started their history with a 6–0 win at Yankee Stadium.

Ramos was part of the continuing Cuban connection fostered by the Griffith organization, as was another promising hurler. Camilo Pascual had a fastball that could match Ramos's and a curveball that few in the major leagues could match.

Pascual was on the mound for the Twins' first game at Metropolitan Stadium, against the new Washington Senators. He didn't get a decision as the Senators broke a 3–3 tie with two in the ninth off reliever Ray "Old Blue" Moore, but Pascual went on to lead the league in strikeouts for the first of three consecutive seasons.

The other end of the battery was a sturdy and steady catcher, Earl Battey. Remembered as bulky, Battey was a talented athlete who once turned down an offer to play basketball for the Harlem Globetrotters. Behind the plate, Battey won Gold Gloves and kept runners nervous with his quick and powerful pickoff throws. At the plate, he was one of the top-hitting catchers in baseball.

Jim Lemon, who had hit thirty-eight home runs the year before in Washington, was slowing down and never produced much for the Twins. However, two younger players on their way up had big years.

Bob Allison, the 1959 American League Rookie of the Year, hit twenty-nine home runs and showed off a strong arm in right field.

The team's main attraction was Harmon Killebrew, although it took a while for home fans to see him play. Killebrew pulled a hamstring muscle the first week of the season and missed the

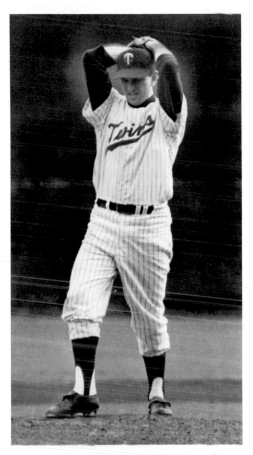

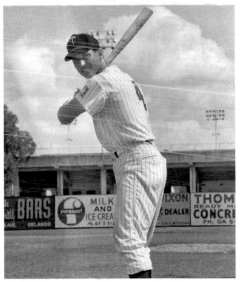

Top: Camilo Pascual was the top pitcher during the Twins' first three years in Minnesota. *Minnesota Twins.*

Right: Bob Allison was a heavy hitter for Minnesota in the 1960s. *Minnesota Twins.*

THE TWINS' FIRST OFFICIAL game was memorable—a 6–0 shutout of the Yankees in New York. Less remembered is the Twins' first game of any kind a month before that, at Tinker Field in Orlando, Florida, the team's spring-training home. Orlando mayor Robert Carr threw out the ceremonial first pitch, and the first pitch ever thrown in the history of the Minnesota Twins came from Paul Giel. A native of Winona, Minnesota, Giel had been an outstanding football and baseball player at Minnesota (he was runner-up for the Heisman Trophy in football his senior year) and had pitched for the New York Giants and Pittsburgh Pirates. The 1961 season was Giel's last in baseball. He later became the sports director at WCCO Radio in Minneapolis and, later, the athletic director at the University of Minnesota.

An appropriate choice for the honor of the team's first pitch, Giel was the losing pitcher in the game. The Detroit lineup was missing some key players—Al Kaline, Rocky Colavito and Norm Cash—who didn't make the trip from nearby Lakeland to Orlando, but George Thomas did some damage with a two-run triple off Ray Moore in the eighth. Thomas was a native Minnesotan and later became the head baseball coach for the Minnesota Gophers.

next two weeks. In his first appearance at Met Stadium, at the end of April, he had four hits, including a home run off the batter's eye beyond the center-field fence, estimated at 450 feet. (At Met Stadium, distances of home runs were measured to the point of impact, not based on how far they would have traveled unobstructed as they were at later stadiums.) It was Killebrew's first of forty-six home runs in 1961.

The Twins started well, winning five of their first six and nine of their first twelve to take over first place, and manager Cookie Lavagetto made the cover of *Sports Illustrated*. However, by the magazine's publication date of May 15, the Twins were starting a stretch during which they lost eighteen of twenty games. In early June, with the Twins in New York, Lavagetto was called back to Minnesota by Calvin Griffith and put on furlough. He returned to the dugout a week later but didn't last much longer. By the end of the month, Lavagetto was fired, and coach Sam Mele, who had guided the team during the furlough period, was promoted to manager. Mele

brought a fire that may have been lacking in Lavagetto but also a calming influence as he worked with Griffith in blending rookies and veterans over the next few years to raise the Twins in the standings.

A pair of season highlights came during a Fourth of July double-header against Chicago. The Twins won the first game 6–4 as Julio Becquer hit a two-out grand slam in the last of the ninth. The sweep was completed with a 4–2 win in which Harmon Killebrew hit a three-run inside-the-park home run. The excitement of having a major-league team was enough to satisfy the fans, even though Minnesota finished in seventh place with a 70-90 record.

Just before the 1962 season, the Twins got a boost by trading Ramos, who had been holding out, to Cleveland for left-hander Dick Stigman and first baseman Vic Power. Stigman, who had been a fine amateur pitcher in his hometown of Nimrod, Minnesota, was effective as a starter and out of the bullpen for the Twins. Power was a slick-fielding first baseman who had already won four Gold Gloves at that position and would receive three more. A native of Puerto Rico, he had taken the name Power years earlier while playing in Drummondville, Quebec, because his given name, Pellot

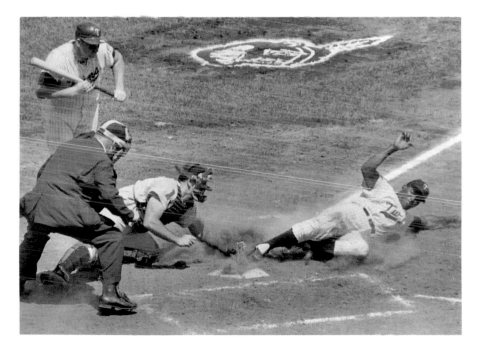

With Harmon Killebrew at bat, Vic Power steals home against Cleveland on July 19, 1962. *Minnesota Twins.*

(pronounced PAY-yo), sounded like a dirty word in French. Known for catching pop-ups with only one hand, he was the bane of youth coaches trying to teach their players to use two hands on flies—although Power's colorful style made him a favorite with the fans.

Joining Power in the infield were Zoilo Versalles, a twenty-three-year-old shortstop from Cuba; rookie Bernie Allen at second base; and, in his first full season, third baseman Rich Rollins, who did so well that at mid-season he received the most votes for the American League All Star team in a poll of the players, coaches and managers. In the outfield, Killebrew and Allison continued to flank Lenny Green.

The Twins didn't miss Ramos, who, despite his Opening Day shutout of the Yankees in 1961, had lost twenty games and led American League pitchers in that category for the fourth straight year. With Stigman making spot starts, the pitching staff was anchored by Pascual, who beat Baltimore 1–0 in the final game of the year for his twentieth win and eighth shutout.

Jim Kaat, a twenty-three-year-old left-hander who had gone 9-17 in 1961, developed as a top starter with eighteen wins. He was known as "Kitty," a play on his name as well as his quickness and grace that earned him the first of sixteen consecutive Gold Gloves starting in 1962.

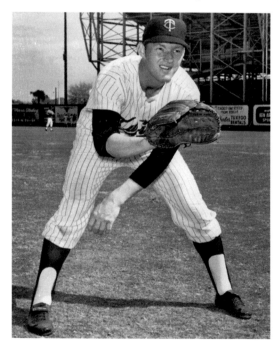

Jim Kaat was the team's best southpaw in the early years. *Minnesota Twins.*

The final piece of the rotation was another southpaw, Jack Kralick, who won twelve games, one of them providing one of the top moments in early Twins history. On Sunday, August 26, Kralick faced the Kansas City Athletics in a pitching duel with Bill Fischer. The A's almost took the lead in the fourth, but Allison robbed Ed Charles of a home run. In addition to keeping the game scoreless, the catch kept Kralick perfect. He was retiring every Kansas City batter he faced and kept doing so, although

Minnesota would have to score to make it meaningful. The Twins finally got a run in the seventh, and now the focus was on Kralick. He put down the side in the eighth and was an inning away from a perfect game, which would have been the first since Don Larsen in the 1956 World Series and the first in the regular season since 1922. Facing the bottom of the order, Kralick got Wayne Causey to ground out to start the ninth. Catcher Bill Bryan was due up, but George Alusik hit for him, worked the count full and then fouled off a pitch. The next

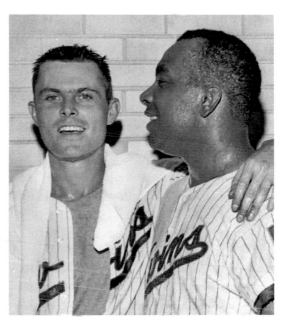

Jack Kralick celebrates his no-hitter with catcher Earl Battey on August 26, 1962. *Minnesota Twins.*

pitch was a ball, and Alusik walked. His perfect game gone, Kralick still had a no-hitter. He also had only a one-run lead, and the outcome of the game remained on the line. Pinch hitter Billy Consolo fouled out to Power, and Bobby Del Greco did the same. Kralick had his no-hitter.

Beyond the individual performances, the Twins as a team were good. No one, it seemed, had high hopes of wrestling the pennant from the New York Yankees. The Twins didn't appear likely to be a contender after losing six of their first eight games, but they soon were in the mix. Minnesota briefly moved into first place in June and at mid-season was in the battle for the top with Cleveland, New York and the Los Angeles Angels, a surprising contender as a second-year expansion team.

Along with Pascual, Killebrew carried the load, leading the American League with forty-eight home runs. By September, the Twins had pulled away from everyone but the Yankees. New York clinched the pennant in the final week of the season and finished five games ahead of Minnesota, which won ninety-one games.

The Twins won ninety-one games again in 1963, although this time it put them only in third place and left them thirteen games behind the first-place

Yankees. New York had a powerful team again, although Minnesota more than matched it in long balls. The Twins hit 225 home runs, a team record that has yet to be equaled and the second-highest total for any team in a season at that time. (The 1961 Yankees had hit 240 homers.)

Allison and Killebrew were the two most productive hitters in the American League that season. Allison hit thirty-five home runs and led the league in early August. Killebrew, who missed most of the first month of the season with a bad knee, eventually overtook Allison and finished with forty-six home runs.

Earl Battey had his best year at the plate, hitting twenty-six homers, and a new center fielder, Jimmie Hall, hit thirty-three, breaking the American League record held by Ted Williams for the most home runs by a first-year player.

In the first game of an August 29 double-header at Washington, Killebrew and Power each hit two homers, and Rollins, Hall, Allison and Allen each hit one. The Twins tied a major-league record with eight home runs in the game and then added four more in the second game.

On the mound, Pascual, despite missing time with a pulled muscle in his shoulder, led the starters with twenty-one wins. And much of the fun at the Met in 1963 came with the entry of a relief pitcher to the organ melody of the song "Won't You Come Home, Bill Bailey?" The reliever was Bill Dailey, whom the Twins had purchased from Cleveland just before the season opened.

Dailey is rarely mentioned in discussions about the best relief pitchers in Twins history, although in his time, starting pitchers went the distance more frequently and bullpen help was summoned only when needed. Not "closers," the relievers who stood out then were "firemen," who often got their team out of a jam, sometimes as early as the sixth or seventh inning, and then pitched the rest of the game.

Baltimore's Stu Miller and Chicago's Hoyt Wilhelm, the first reliever to make it to the Hall of Fame, were among the top bullpen aces in the league that year, but in 1963, the best in the American League were Dailey and Dick Radatz of the Red Sox. Nicknamed the "Monster," the six-foot-six Radatz was familiar in Minnesota, having pitched for the Minneapolis Millers three years before. On July 10, Radatz took the mound in the seventh at Met Stadium; Dailey did the same for the Twins with the score tied 4–4. The two matched three scoreless innings, and the game stayed tied after nine. Boston finally got to Dailey in the top of the tenth, and the Red Sox and Radatz won that battle, although the fans were greatly entertained by these two dominant pitchers.

Saves were not an official statistic in 1963, although unofficially, the *Sporting News* credited Dailey with thirteen saves, applying a more stringent criterion than is used today. Dailey's save total may not look like much in contrast to the numbers of modern closers, but Dailey's job was usually to come in to stop a rally, not start the final inning of a game with as much as a three-run lead. He had a 1.99 earned-run average (ERA) in 108⅔ innings, pitching more innings than Mariano Rivera or Trevor Hoffman, now the leaders in career saves, ever did in a single season in his career.

The Twins drew over 1.4 million fans at home in 1963 (during a period when 1 million was a sign of success) and led the American League in attendance.

In a pre-season poll in 1964, the Twins were picked to finished second to the Yankees. Allison and Killebrew were among the team leaders again. Killebrew had his best season in home runs, hitting forty-nine, while Allison had thirty-two. The batting order was bolstered by Tony Oliva, considered a rookie that year although he had played near the end of the year the previous two seasons. From the province of Pinar del Rio in Cuba, Oliva led the league with a batting average of .323 and 109 runs scored. He had power to all fields, hitting thirty-two home runs and driving in 94. His 217 hits were the most in the majors, and Oliva broke Joe DiMaggio's American League rookie record with 374 total bases.

The Twins hit 221 home runs, nearly matching their total from the previous year, and had four in a row—by Oliva, Allison, Hall and Killebrew—in the tenth inning of a game in Kansas City in early May. Unfortunately for Minnesota, Bill Dailey couldn't anchor the relievers as he had before, and the bullpen wasn't reliable until the team purchased veteran Al Worthington in late June. By then, the defense was having problems, with the Twins having lost twenty-four games in which unearned runs allowed made the difference between victory and defeat.

With the fielding and pitching unable to keep up with the hitting, the Twins dropped to a sixth-place tie with a record of 79-83.

Despite struggling for much of the season, New York won the pennant for the fifth straight year. As usual, the Yankees were expected to top the league again in 1965. However, the players on the team were showing their age. No one knew it then, but the Yankees' dominance was over. A new team was ready to take command in the American League.

A MAGICAL SEASON

Sam Mele managed the Twins from 1961 to 1967. *Minnesota Twins.*

The beginning of the Twins' march to the American League pennant in 1965 started with a 5–4 win over the defending league champions on Monday, April 12, at Met Stadium. It was also the beginning of the end of the New York Yankees' dynasty. Over the past forty-four seasons, the Yankees had won the pennant twenty-nine times and the World Series twenty times. Their Opening Day lineup in 1965 still had the core of the teams that had won the last five American League titles: Mickey Mantle, Roger Maris, Tony Kubek, Clete Boyer, Bobby Richardson, Elston Howard, Joe Pepitone, Tom Tresh and pitchers Jim Bouton and Whitey Ford.

But the loss to the Twins that day was the first of eighty-five for the Yankees, resulting in a drop to sixth place in the ten-team American League and the beginning of a twelve-year drought.

The opening game is remembered for the ups and downs of Cesar Tovar, who made his major-league debut when he entered the game in the fourth inning for Rich Rollins, who had twisted his knee. Minnesota carried a 4–3 lead into the ninth, but with two out, Tovar dropped Pepitone's pop-up, allowing the tying run to score. However, Tovar came back with a two-out, bases-loaded single in the eleventh to give the Twins the win, the first of 102 during the regular season.

"I'm going to clean house," Calvin Griffith had said after the 1964 season before moving forward with a lot of trading, mostly internally. The biggest shakeup took place among the coaches. Griffith brought in Johnny Sain as pitching coach. After World War II, Sain had three straight seasons with at least twenty wins for the Boston Braves. (Sain and another ace, Warren Spahn, became the subject of a poem by Gerry Hern of the *Boston Post* that

A CROWD OF BARELY fifteen thousand was on hand for the season opener to watch and shiver, as the temperature was only forty-four degrees when Jim Kaat delivered the first pitch at 1:38 p.m. Yankees starter Jim Bouton struggled in the cold and has traced his arm problems to this game. Unable to continue as a power pitcher, he eventually developed a knuckleball and achieved greater fame for his book, *Ball Four*, a diary of the 1969 season.

No one sat in left field as a double-decked grandstand was being built to accommodate more fans for the NFL's Minnesota Vikings. Construction workers were on the job, though, and one was able to corral a souvenir when Elston Howard homered in the fifth inning.

The teams were scheduled to play again the following day, although the advance sale for the game was paltry, and it was apparent that the Twins would come out better if the game were rescheduled as part of a double-header in July. The cold weather by itself might not have been enough to postpone, but another reason was available. During the opener, the Twins made the announcement that the next day's game would not be played because of traffic difficulties due to heavy flooding in the area.

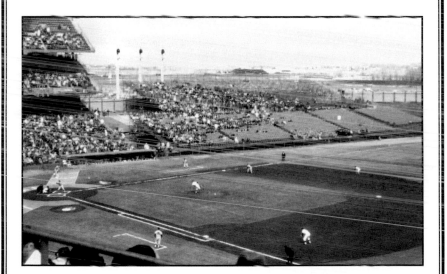

Jim Kaat delivers the first pitch of the pennant-winning 1965 season to Tom Tresh of the New York Yankees. *Author's collection (photo by Howard Thornley).*

The Mississippi River had reached its all-time high level, and the Minnesota River, which flowed south of Metropolitan Stadium, had caused the closure of the Cedar Avenue bridge, resulting in backups elsewhere that affected several Twins: Rollins, Kaat, Dick Stigman and Bill Bethea. (Bethea was awaiting assignment to the minors and staying with the Kaats for a few days.)

Kaat called on a former teammate for help. Paul Giel, who had been with the Twins in 1961 and was by this time the sports director at WCCO Radio, arranged for a helicopter to be sent to Burnsville. Kaat and Rollins got an airborne shuttle to the ballpark, and the helicopter returned to pick up the others.

In this manner, Kaat got to Met Stadium in plenty of time for the first game. He would have also earned the pitching victory if not for Tovar's error.

morphed into a refrain for the Braves team that won the National League pennant in 1948: "Spahn and Sain and pray for rain.") Sain later pitched for the Yankees and became their pitching coach before going back to his home in Walnut Ridge, Arkansas, where he owned a farm and auto parts store. Griffith lured Sain back to baseball to replace Gordon Maltzberger.

Another swap involved the duties of Floyd Baker and Billy Martin. While Baker went from coaching to scouting, Martin returned to uniform with the Twins. He had last played with the Twins and retired during spring training in 1962. He became a scout for the team and in 1964, in addition to working as an extra coach during spring training, had supervised the Midwest scouts (while supplementing his income with a public relations job with a Twin Cities brewery).

In addition to coaching third, Martin was to work with the team on its baserunning. The Twins swapped power for speed in 1965, dropping to 150 home runs but scoring more runs as they doubled their previous total of stolen bases to ninety-two.

Killebrew, who had played the outfield the last few seasons, swapped positions with Bob Allison, who had moved to first in 1964 to make room for Tony Oliva in right. Although not a flashy fielder, Killebrew was versatile enough that he was able to also play third, allowing Sam Mele to insert Don Mincher at first against right-handed pitchers.

Given a chance in a platoon role, Mincher produced. He had hit twenty-three homers the year before and hit twenty-two in 1965. He was particularly valuable to the Twins in the pennant-winning year after Killebrew was injured in early August. Mincher was one of the players with whom Billy Martin worked during spring training in 1964, and in 1965, Martin was credited with the emergence of Zoilo Versalles.

Versalles had grown up in the Marianao District of Havana in a one-room apartment with his parents and brother. Leaving school in second grade to help support his family, Versalles showed talent in baseball, made it onto a top semipro team when he was fifteen and was signed to a professional contract by Joe Cambria three years later. Versalles made the majors in 1959 after Cambria's lobbying of manager Cookie Lavagetto got him a chance in spring training. When the Senators moved to Minnesota, Versalles became the Twins' regular shortstop. His talents were evident but not always consistent. In 1965, Martin told Versalles that he was going to be the most valuable player in the American League that year. Versalles at first thought he was kidding, but he grew closer to Martin, who was able to bring out the best in him.

The shortstop had been fined by Mele during spring training for lackadaisical play, compounded by Versalles's deference to Martin rather than the manager, but he became a leader during the regular season. Out of the leadoff spot, Versalles led the league with 126 runs, forty-five doubles, nineteen triples and 308 total bases. He also hit nineteen home runs, was awarded a Gold Glove and received the American League MVP award, the first Twins player to receive that honor.

On the mound, Pascual got off to a good start, winning his first eight decisions in 1965 before being shelved by a torn muscle in his back. Jim Perry stepped in and won twelve games. Perry was an effective right-hander, although his managers had wavered on whether to use him as a starter or a reliever, and it would be several more years before he found a regular spot in the rotation. The Twins had traded Jack Kralick to get Perry from the Indians in 1963, one of a number of deals with Cleveland that worked out well for the Twins.

Another such deal was the acquisition of Jim "Mudcat" Grant from Cleveland in 1964. Helped by Sain, Grant developed a new pitch called a "fast curve" and became the pitching leader for the Twins in 1965, winning twenty-one games, including six shutouts. Kaat added eighteen wins to go with a 2.83 ERA in 264⅓ innings pitched.

Worthington and another veteran, Johnny Klippstein, were outstanding in relief as the Twins had one of the better pitching staffs in the league to

THE 1965 ALL STAR GAME was held at Metropolitan Stadium. The excitement of the national attention on Minnesota was bolstered by the possibility that it would return that fall for the World Series. The game brought the chance for fans to see National League stars, including some who had played in exhibition games in the Twin Cities and/or in the minors. Willie Mays was in the latter category, having played for the Minneapolis Millers in 1951, and Mays led off the game with a home run. The National League built a 5–0 lead, but the American League came back, tying the game on a two-run homer by Killebrew in the fifth inning before eventually losing 6–5.

The game featured fifteen players now in the Hall of Fame (as well as Pete Rose, who became the all-time hits leader but became ineligible for the Hall after being banned from baseball). In addition, Mickey Mantle and Carl Yastrzemski were on the American League squad but unable to play because of injuries. Also, American League manager Al Lopez made it to the Hall of Fame.

The National League had most of the future Hall of Famers (thirteen), in part an indication of the greater progress the league had taken in integrating over the previous two decades. All three A.L. players who made the Hall (Harmon Killebrew, Brooks Robinson and Al Kaline) were white, while nine of the thirteen National Leaguers (Mays, Hank Aaron, Willie Stargell, Roberto Clemente, Ernie Banks, Juan Marichal, Frank Robinson, Billy Williams and Bob Gibson) were black. Ron Santo, Don Drysdale, Joe Torre and Sandy Koufax were the other four future Hall of Famers for the N.L.

In addition to Killebrew, the Twins had five players on the All Star team: Mudcat Grant, Tony Oliva, Zoilo Versalles, Earl Battey and Jimmie Hall.

go with an offense that produced nearly one hundred more runs than the next-closest team.

While the weather had stayed cold in the early part of the season, the Twins remained hot, although they had plenty of company in the battle for the top. Going into July, only four games separated Cleveland, Minnesota, Chicago, Baltimore and Detroit at the top of the standings. On July 3, the Twins tied the Indians for the lead, took sole possession of first two days later and stayed there the rest of the season.

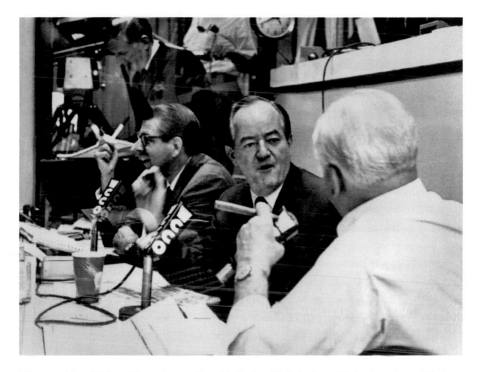

Vice-president Hubert Humphrey talks with Halsey Hall during a Twins broadcast. Herb Carneal is in the background. *Minnesota Twins.*

One of the biggest moments in the team's history came on Sunday, July 11. The Yankees had scored an unearned run in the top of the ninth to take a 5–4 lead. In the bottom of the inning, Killebrew came up with one on and two out and homered to left. The 6–5 win put the Twins five games in front going into the All Star break.

Killebrew was having another big year when he was hurt in a collision at first base on August 2 and missed the next seven weeks with a broken elbow. The Twins kept rolling, though, and were in command when Killebrew returned on September 21. Five days later, in Washington, the Twins beat the Senators to clinch the pennant.

At the time, San Francisco and Los Angeles were tied for first in the National League, but the Dodgers finished the final week with six wins in seven games to jump ahead of the Giants.

Led by Sandy Koufax and Don Drysdale, Los Angeles was a team that relied on pitching. Koufax, a twenty-six-game winner, would have been the pick for the World Series opener, but the game fell on Yom Kippur, and

Drysdale got the call as Koufax reportedly spent some of the day at a Twin Cities synagogue and avoided the ballpark. (John Rosengren, author of a book on Jewish baseball star Hank Greenberg, noted that nearly every rabbi in the area claimed Koufax attended his synagogue, although it is possible that Koufax went to Temple of Aaron in St. Paul.)

The Twins jumped on Drysdale in the last of the third, breaking a 1–1 tie with six runs, a rally that included a three-run homer by Zoilo Versalles. Koufax was back for the second game and pitched well, giving up two runs, one of them unearned, through six innings. Kaat, as had Grant the day before, went the distance, getting help from a sliding catch by Allison in left on a drive by Jim Lefebvre with one on and no outs in the fifth. Minnesota won the game 5–1 to take a two-game lead.

The Dodgers bounced back, winning all three games in Los Angeles as the Twins scored only two runs, on home runs by Killebrew and Oliva. The series came back to Minnesota with the Twins facing elimination.

Grant came through in the sixth game, pitching another complete game and adding a three-run homer for a 5–1 win. In the seventh game, Koufax and Kaat met again for the third time in the series with both working on only two days' rest. However, Kaat had pitched only 2⅓ innings in the fifth game, while Koufax had gone the distance with a four-hit shutout.

Koufax was magnificent again, holding the Twins to three hits, and the Dodgers knocked Kaat out of the game with two runs in the fourth. Los Angeles took the game 2–0 to win the World Series.

Though not a world championship, a pennant in the years before the leagues were broken into divisions was impressive and fondly remembered.

Good, But Not Good Enough

Although the Twins followed their league championship with a second-place finish, they were never in the race in 1966. A poor first half, accentuated by the drop-offs in performance by Versalles and Grant, left Minnesota nineteen games out of first in early July. A strong finish lifted them in the standings, and the Twins finished nine games behind the Orioles, who then swept the Dodgers in the World Series. Killebrew finished second in home runs and RBIs to Frank Robinson, who won the Triple Crown (leading the league in batting average, home runs and RBIs) in his first season with Baltimore, helping an already good team become world champions.

Two players—Chuck Schilling and Davis May—have been on the active roster for the Minnesota Twins but never played a regular-season game for the team.

The Twins acquired Schilling, who had played five seasons for the Boston Red Sox, along with Russ Nixon from Boston for Dick Stigman prior to the 1966 season. A second baseman, Schilling didn't get into a game as Bernie Allen and versatile Cesar Tover played second for the Twins.

In May, the Twins sent Schilling and outfielder Ted Uhlaender to the minors to cut down to the required twenty-five-player roster. (At that time, teams could open the season with more than twenty-five players.)

Although he never played for the Twins, Schilling at least had played in the major leagues. That wasn't the case with Davis May eleven years later.

A right-handed pitcher, May was the last player cut by the Twins before the regular season opened in 1977. The team had just purchased another right-hander, Don Carrithers, from Montreal and sent May to Triple-A Tacoma.

In the early morning hours of Monday, April 25—a few hours after the Twins had flown home from Texas—Carrithers and another pitcher, left-hander Mike Pazik, were seriously hurt when a vehicle driving the wrong way on a freeway ramp near Metropolitan Stadium collided with Carrithers's Volkswagen van. Later that day, the Twins called up May and left-handed pitcher Jeff Holly.

Holly made his debut in a big way the following Sunday, pitching seven scoreless innings of relief and getting the win when the Twins scored four runs in the last of the ninth to beat Detroit. May never got his chance, however. He warmed up in the bullpen on occasion, but manager Gene Mauch never put him in. On Monday, May 16, May was returned to Tacoma to make room for Glenn Adams, who was returning after having broken his wrist the previous month.

May remained in the Twins organization through 1978 and pitched in the minors in the Toronto and Cincinnati organizations in 1979 and 1980, but he never made it to the majors.

ONE GAME IN THE MAJORS

Fred Bruckbauer was the second major leaguer born in New Ulm, Minnesota, although he had grown up in nearby Sleepy Eye. He played amateur baseball for the New Ulm Brewers in the Minnesota River League, as well as with the Sleepy Eye Indians in both the Western Minnesota League and Minnesota River League. Bruckbauer was an outstanding pitcher for the Minnesota Gophers in 1958 and 1959. After being watched by Washington Senators scout Angelo Giuliani, he had a tryout with the Senators that resulted in him signing a contract with the team in June 1959, following the conclusion of his junior season at the University of Minnesota.

The Senators moved to Minnesota in 1961, which is when Bruckbauer got his chance in the majors. Bruckbauer's only game came on Tuesday night, April 25, 1961, when the Twins played the Athletics in Kansas City. With the Twins down 7–0, Bruckbauer started the fourth inning. He gave up a double to Dick Howser and a run-scoring single to Jay Hankins. Jerry Lumpe walked, and Lou Klimchock doubled to score two runs to end Bruckbauer's night and his career in the majors. Kansas City won the game 20–2, and Bruckbauer ended his career with an ERA of infinity. (The previous New Ulm–born player, Elmer "Doc" Hamann, also pitched only one game in the majors, for Cleveland on September 21, 1922. Hamann did not retire a batter and, like Bruckbauer, has a career ERA of infinity. A later New Ulm–born player, Terry Steinbach, did better in his debut—he homered in his first at bat.)

A bright spot for the Twins was Kaat, who won twenty-five games and might have received the Cy Young Award had it been awarded to pitchers in both leagues. (Until 1967, the award was presented to only one pitcher; Sandy Koufax received it for the third time in his career in 1966.)

Kaat was a crafty pitcher and smart enough to rely on advice from others. During a July 1963 exhibition game in Milwaukee, Kaat had a productive visit with the Braves' great southpaw Warren Spahn, who recommended a "toe-to-toe" method of pitching. "By stepping off my left toe and down to my right toe, I could get a lot more body into the pitch," said Kaat, who often referred to this style as a reason for his increasing success.

In 1965, Kaat had found another mentor in Sain, who had a record of success as a pitching coach as well as a reputation for not getting along with managers. In Minnesota, Sain battled with Mele as well as Billy Martin, a clash that resulted in Sain and Hal Naragon, another coach and a Sain confidant, getting fired after the 1966 season.

Kaat, who had won forty-three games in the two years Sain was with the Twins, wrote an open letter to fans that was printed in the October 6, 1966 *Minneapolis Tribune* denouncing the dismissals. "This is the worst thing that could happen to our club at this time," Kaat wrote. "We had the finest pitching coach money can buy, and now, suddenly, he's gone. I think the fans should know what a huge void we have to fill."

Kaat later reunited with Sain on the Chicago White Sox in the 1970s and had two more seasons of at least twenty wins.

The 1967 season is remembered for the great pennant race in the American League. The Twins had shored up their pitching with a pair of trades, getting Dean Chance from the Angels for the rotation and Ron Kline from Washington to bolster their bullpen. Chance pitched a no-hitter in Cleveland in August (after having pitched a rain-shortened perfect game

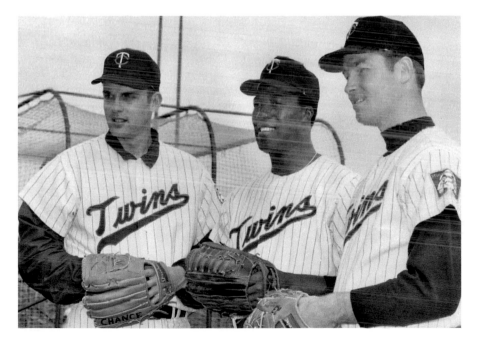

Dean Chance, Jim "Mudcat" Grant and Dave Boswell were all twenty-game winners for the Twins. *Minnesota Twins.*

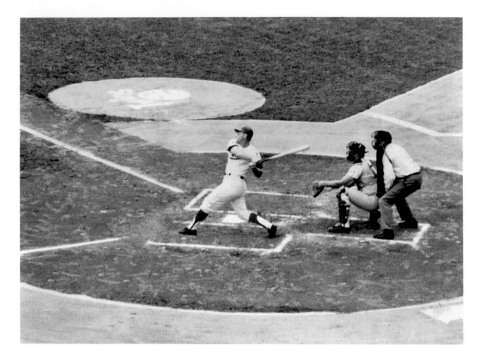

One of the most majestic sites at Metropolitan Stadium was a Harmon Killebrew home run. *Minnesota Twins.*

earlier in the month) and won twenty games. Chance, Kaat and Dave Boswell all struck out more than two hundred batters for the Twins.

Winning the Rookie of the Year Award in '67 was second baseman Rod Carew, who was starting a career that would take him all the way to the Hall of Fame. Carew grew up in New York and was signed, almost under the noses of the Yankees, by Twins scout Herb Stein. Harmon Killebrew also had another big year, pounding forty-four home runs, although he was upstaged by Boston's Carl Yastrzemski. Yaz, who had played with the Minneapolis Millers during the playoffs in 1959 and throughout 1960, led the league in batting average and RBIs and tied for lead in home runs, earning him the Triple Crown.

It took a while for the Twins to get going in 1967, however. Another slow start cost Sam Mele his job in June, and Cal Ermer was brought in as his successor. The team sputtered for another two weeks under the new manager and also had an incident with racial overtones on a late night bus ride from the Detroit airport to the hotel. The confrontation simmered and lingered, but Minnesota soon started winning and joined a crowded battle for the

top. The Boston Red Sox were a surprise team in 1967, contending for the pennant after a ninth-place finish the year before. The Chicago White Sox had held the edge for much of the first part of the season, and the Detroit Tigers (who now had Sain as their pitching coach) were also in the race.

These four teams fought for first place into the final weekend. The Twins were at Boston for two games, needing just one win to eliminate the Sox. Jim Kaat, who had already won seven games in September, was in control in the first game of the series before having a tendon pop in his elbow. With Kaat having to come out, the Twins lost the game. The following day, Chance couldn't hold a 2–0 lead after five and a half innings. The Red Sox won the game and, thanks to a Detroit win a little later, the pennant.

Yastrzemski easily won the league's MVP award in 1967, although it wasn't unanimous. Max Nichols of the *Minneapolis Star* drew a strong—and negative— reaction by casting his first-place ballot for Cesar Tovar of the Twins. Tovar, in setting an American League record by playing in 164 games (the Twins had two tie games that season that had to be replayed), came to the plate more than any other hitter, although his overall offense was slightly below average. Nichols cited Tovar's play in the field (and all over

Cesar Tovar was one of the most versatile players in Twins history. *Minnesota Twins.*

the field) as the reason for his value; the utility man played seventy games in the outfield, seventy at third base, thirty-six at second and nine at shortstop, often playing in more than one spot in a game. "It's one thing to play a position, but another to play it well," wrote Nichols. "Tovar played three positions—second, third, and left field—better than anybody we ever had since the club came to Minneapolis in 1961." The Twins players backed up Nichols by voting Tovar as the most valuable member of the team that year, over Killebrew, Chance and Carew.

In 1968, Kaat reinjured his elbow tendon during spring training and missed the first part of the season, but Minnesota won its first six games. From there, the team nosedived. A serious hamstring injury to Killebrew in the All Star Game didn't help, although the lack of a reliable shortstop was also a factor in the decline. Jackie Hernandez couldn't do the job with his glove or bat, and a variety of others were tried. Tovar (who completed the home season by playing all nine positions in one game) filled in at shortstop but was needed to plug other holes. Even Carew was moved from second base to shortstop for four games. With the team's drop to seventy-nine wins and seventh place in 1968, Griffith fired Ermer. His replacement was a popular choice, Billy Martin, who had left the coaching staff during the season to manage in the minors.

Along with Martin's first season of a twenty-year managerial career splashed with success and saturated with turmoil, 1969 brought additional expansion and the breaking of the leagues into six-team divisions. Both of the American League newcomers, the Seattle Pilots and Kansas City Royals, were assigned to the West with the Twins. Only one team in that division, the Oakland Athletics (who had moved from Kansas City after the 1967 season), had finished ahead of Minnesota the year before. The dominant teams, Baltimore and Detroit, were in the East, giving Twins fans a deserved dose of optimism.

Not surprisingly, with Martin as the manager, the Twins ran more in 1969. Tovar stole forty-five bases, and Rod Carew stole home seven times (then considered a league record, although it later was discovered that Ty Cobb had stolen home eight times for the Detroit Tigers in 1912). Even Killebrew got in on the act, stealing eight bases; many were the result of trailing Carew on a steal, but three were on his own.

Killebrew also did what he did best—getting on base with a hit or walk, hitting home runs and driving in runs. With forty-nine home runs and 140 RBIs, Killebrew was voted the American League MVP. In addition to his steals, Carew led the league in batting average for the first of seven times in his career.

Jim Perry, finally with a steady spot as a starter, won twenty games, as did Dave Boswell, who might be better remembered for a fight with Martin outside a Detroit bar in August.

The Twins won the West by nine games over Oakland. In the best-of-five league playoffs, they were swept by Baltimore, although they took the Orioles, who had won 109 games in the regular season, to extra innings in the first 2 games.

After the season, Griffith let Martin go as manager. The fight with Boswell in Detroit may have been a factor, but it wasn't the only issue involving the behavior of the manager, who had similar problems with other teams he managed after that.

However, Griffith's refusal to renew Martin's contract didn't go over well with the fans. Some vowed to never attend Twins games again, and perhaps a few followed through, although the pattern for Twins attendance has normally followed the fortunes of the team on the field. So it was in 1970 when the Twins, under manager Bill Rigney, won the West Division again.

Minnesota overcame a number of injuries, the biggest involving Carew. The Twins second baseman was carrying a .376 batting average when he tore ligaments in his knee when hit by a rolling block by Mike Hegan while turning a double play in Milwaukee on June 22. Carew missed three months because of the injury.

Killebrew had another big season, hitting forty-one home runs, and Jim Perry had an even bigger year, winning twenty-four games and becoming the first Twins pitcher to receive the Cy Young Award. Dave Boswell, the other twenty-game winner from the year before, was ineffective, but the staff was helped by the addition of a nineteen-year-old right-hander with a great curveball, Bert Blyleven, who was called up from the minors in June

Jim Perry was the first Twins pitcher to win the Cy Young Award. *Minnesota Twins.*

and won ten games. Behind Baltimore, Minnesota had the second-lowest ERA in the league.

The 1970 season had a familiar ending. The Twins finished nine games ahead of Oakland but were taken out in three games by the Orioles in the playoffs.

The first decade in Minnesota produced mostly competitive teams, and the Twins led the league in overall attendance during that period, drawing more than 13 million fans to Met Stadium. However, the Twins were unable to follow their 1965 success with a second pennant as other teams, notably Baltimore, improved. Dan Levitt and Mark Armour, in *Paths to Glory: How Great Baseball Teams Got That Way*, cited the rise of the Orioles, constant position shifts of some players (particularly Tovar), mediocre defense, team turmoil (including racial divisions) and a surprisingly rapid decline of several regulars (Hall, Rollins, Allison, Battey and Versalles among them) as the reasons, concluding, "A number of factors, some controllable by the club and some outside its influence, combined to thwart a second pennant over the last half of the decade."

CHAPTER 3

FIGHTING FOR RELEVANCE

SINKING IN THE WEST

In a players' poll taken after the 1971 season, the Minnesota Twins were voted the most disappointing team. Sputtering starts by some players and injuries combined to kill a lot of fan interest in the early part of the season.

The downfall of the Twins coincided with a surge from Metropolitan Stadium's other occupant, the Minnesota Vikings. The state's pro football team had won the National Football League title in 1969 and gone to the Super Bowl. The string of division championships continued, and over an eight-year span starting in 1969, the Vikings were in four Super Bowls. Even though they never won the overall championship, the success of the Vikings captured the local sports scene, leaving other teams, such as the Minnesota Gophers and Minnesota North Stars of the National Hockey League, clamoring for the remnants of space on the sports pages and attendance by the fans.

The Twins didn't fare well in this mix.

In 1971, Harmon Killebrew hit the 500th home run of his career. The milestone wasn't surprising, but the timing was. Killebrew entered the season with 487 homers. Instead of reaching 500 in the first two months or even the first half of the year, he was still two short at the end of June. By this time, the Twins had scheduled July 6 as the night to give away a commemorative coffee mug to honor his achievement. Not only was he not there yet, but

A THING OF THE PAST, in-season exhibition games for major-league teams used to be common as teams played their minor-league affiliates or a team from another league on a regular basis. The Twins once had an exhibition game against a league rival, the White Sox, in Milwaukee during a season in which Chicago and Minnesota were battling in one of the best American League pennant races ever. The game, in July 1967, drew more than fifty-one thousand people, including several thousand who lined the outfield in a roped-off area. With a rumor that the Kansas City Athletics might move to Milwaukee, a city that had lost the Braves to Atlanta the year before, fans wanted to show support for another major-league team.

The Twins had played an exhibition game in Milwaukee, against the Braves, four years before that. Exhibition games provided an opportunity for pre-game events that were rare at the time. Catchers Earl Battey, Jerry Zimmerman, Del Crandall and Joe Torre had an accuracy contest, throwing balls from behind home plate into a barrel resting on second base. Bobby Bragan beat Sam Mele in the managerial bunting contest. The coaches from both teams, blindfolded, pushed a wheelbarrow from behind the mound to as close as they could get it to home plate.

The highlight, however, was a home run contest that included Hank Aaron, who was leading the National League in home runs,

The Twins and Milwaukee Braves prepare for an exhibition game at County Stadium on July 22, 1963. *Author's collection (photo by Howard Thornley).*

and Harmon Killebrew and Bob Allison, who were tied for the American League lead in homers at the time. Aaron edged out Killebrew in the contest.

Killebrew was in another memorable derby eight years later, this one against Willie Mays before an exhibition game against the Giants at Met Stadium. Mays, who had played for the Minneapolis Millers twenty years before that, won the contest, although Killebrew homered in the game. (The Twins-Giants exhibition game occurred the night before Killebrew hit his 500th home run.)

With the introduction of inter-league play in 1997, fans in all cities now have the chance to see players and teams from throughout the major leagues. Prior to that, however, in-season exhibition games were among the few chances people had to see the stars from the other league, as well as some pre-game antics.

Killebrew wasn't even in the lineup the night the cups went out as he was dealing with a toe injury that was either keeping him out of the lineup or hampering him when he was in it. Still, the Twins drew their second-largest crowd of the year to that point because of the promotion.

When Killebrew finally hit number 500, on August 10, he broke the logjam. He hit another home run in the same game and then doubled his season output the rest of the way to finish with 28 home runs and a league-leading 119 RBIs.

Another star who struggled early was Carew. Still recovering from his knee injury, Carew also dealt with a mid-season position shift that was quickly abandoned. Rigney, both thinking that Carew was gun-shy on pivots at second and wanting to reduce the risk of collisions, moved him to third base. Carew played two games there, sandwiched around a weekend when he was gone for U.S. Marine Reserve meetings, and looked as awkward as he was uncomfortable. Carew returned to playing second, eventually got his stroke at the plate and ended the season with a .307 batting average.

Despite the downturn of the team, several players stood out. Blyleven had the fifth-best ERA in the league and won sixteen games, a total that could have been higher with better run support from his mates. Tovar, with a regular spot in the outfield and the versatility to still fill in at other spots, had a batting average of .311 and led the league with 204 hits. The best

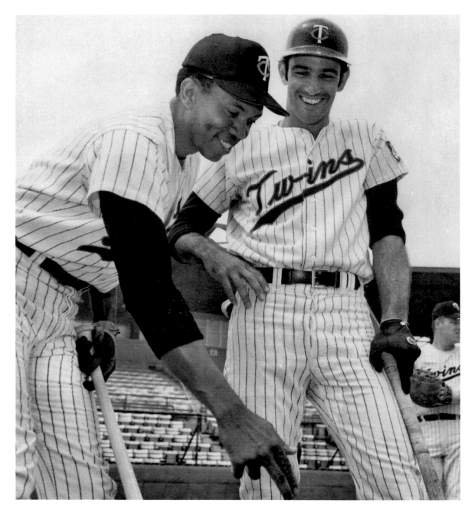

Leo Cardenas and Frank Quilici. *Minnesota Twins.*

Minnesota player that year, however, was Leo Cardenas, who had come to the Twins in a trade with Cincinnati after the 1968 season. Cardenas was steady at shortstop, a position with a void for the team the previous seasons. In 1971, he set an American League record for fielding percentage at that position and tied a major-league record for the fewest errors by a shortstop. In addition to being reliable in the field, he hit eighteen home runs, third on the team behind Killebrew and Oliva.

As for Oliva, the right fielder was having his best of many outstanding seasons with the Twins through the first half of the year. Driving the ball

to all fields, he had his batting average over .375 and had hit twenty-two home runs when he injured his knee in a game at Oakland on June 29. Oliva didn't play again in the outfield for nearly three weeks and wasn't the same player when he returned, although he did end the year with a .337 batting average to lead the American League in that category for the third time. The injury was serious enough to put an end to the spectacular seasons he had been having.

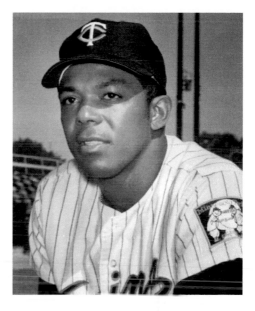

Tony Oliva was one of the best hitters in the American League for many years. *Minnesota Twins.*

The Twins dropped to fifth place in the six-team West Division with a record of 74-86, twenty-one games worse than in 1970. The team had had dips before, but this time the fans didn't stay with them. Attendance was just over 940,000, making it the first of a number of seasons in which the Twins would not draw 1 million.

Over the next three years, the Twins weren't bad, just bland. They had .500 records in 1972 and 1973, a winning record (slightly, at 82-80) the next season, and they finished in third place each year. Getting fans enthused was difficult, especially when the opening of the 1972 season was delayed by a players strike. Minnesota had been scheduled to open the season at home on April 6, which turned out to be a beautiful day for baseball. But the mood of the public and the weather had dampened and chilled by the time of the rescheduled home opener, which was rained out and played the next day in weather that was barely any better.

More than 17,800 showed up for the first game at Met Stadium, but even though the Twins played well during the first part of the year, it was another two months before they drew more fans than that. The team leveled off in June, and the following month, Rigney was fired. Taking over was one of the coaches and a popular player on the Twins prior to that, Frank Quilici.

Minnesota had strong pitching in 1972. The staff finished with a 2.58 ERA, third-best in the league even with the loss of Kaat, who had broken

a bone in his hand while sliding into second in early July. Kaat earned his tenth win (against only two losses) in that game, but his season ended with an ERA of 2.06.

The Twins were only in the middle of the pack in runs scored despite twenty-six home runs by Killebrew and another twenty-two from newcomer Bobby Darwin, a pitcher-turned-outfielder with flashes of great power. (Two years later, Darwin became the only player aside from Killebrew to homer into the upper deck in left at Met Stadium.) Rod Carew led the league in

WYNN AND WILLIAMS: THE MATCHUP THAT DIDN'T HAPPEN

In 1972, the Twins, at least for a time, considered a matchup of two players already in the Hall of Fame.

Early Wynn, who retired in 1963 with three hundred pitching victories, had been a Twins pitching coach and was at this time managing the team's farm club in Orlando in the Florida State League. Wynn had started his major-league career in 1939 and wanted to take the mound for Minnesota to extend his career into five different decades. Had Wynn not been elected and inducted into the Hall of Fame in 1972, he probably would have held off on his desire, since another pitching appearance would restart his five-year waiting period for the Hall. Already in, however, Wynn was looking at becoming the first player to appear in a major-league game as a member of the Hall of Fame in addition to becoming a five-decade performer.

Wynn thought this might prompt Ted Williams, whose major-league career had extended from 1939 to 1960, to similar aspirations. Williams was managing the Texas Rangers, who were scheduled for a two-game series in September, when teams could expand their rosters.

One obstacle to a matchup between the fifty-two-year-old Wynn and Williams, who would be fifty-four by September, was that both players would have to get their releases from the last teams they played for—Cleveland for Wynn and Boston for Williams. Dealing with the reserve clause (which bound players to their teams even after their contracts expired and even after they retired) probably wasn't the holdup, but for whatever reason, the matchup of Early Wynn pitching to Ted Williams in 1972 never happened.

batting average (hitting .318 but without any home runs) for the first of four straight years. The Twins missed Oliva, however. The knee injury the year before had brought his greatness to an end. In 1972, Oliva played only ten games, one as a pinch hitter and nine in the outfield, the last time he ever appeared in the field.

Playing 154 games (missing 8 because of the strike), the Twins had their lowest totals ever in runs, hits, RBIs and home runs. Minnesota finished with a 77-77 record and drew fewer than 800,000 fans.

In 1973, the American League adopted the designated hitter. The impact for Minnesota was that it gave Oliva a chance to keep playing, and he had ninety-two RBIs as a full-time hitter. Killebrew dealt with injuries and had his worst season, hitting only five home runs. By the following season, he was platooning at designated hitter with Oliva. Killebrew finished his career a year after that with the Kansas City Royals instead of the Twins.

Minnesota pitching had a setback in 1973, although Blyleven had a big year, winning twenty games (nine of them shutouts), pitching 325 innings and placing second to Baltimore's Jim Palmer with an ERA of 2.52. He also made the American League All Star team for the first time. It was another

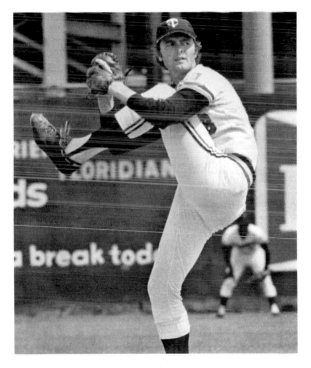

Bert Blyleven, who joined the Twins as a nineteen-year-old in 1970, made fans recall Camilo Pascual with his great curveball. *Minnesota Twins.*

Gene Mauch managed the Minneapolis Millers in the 1950s and became the Twins manager in 1976. *Minnesota Twins.*

.500 season for the Twins, and in 1974, they upped their record (barely) by finishing at 82-80. The winning record wasn't enough to lure back fans, and the team had its worst attendance to that point, with barely 662,000 fans coming to see them at home.

When the Twins dropped to seventy-six wins in 1975, it was the end for manager Frank Quilici. Griffith hired Gene Mauch, who had played for and managed the Minneapolis Millers in the late 1950s. Regarded as a savvy baseball man, Mauch had high hopes, and similar expectations were put on him.

Any interest generated by the new manager disappeared with another mediocre start in 1976. The Twins were eleven and a half games out of first at the end of July, although rookie catcher Butch Wynegar did attract attention. Wynegar made the All Star team, as well as a memorable commercial in which he stated that he loved baseball so much that he would play for free. The spot ended with a smiling Calvin Griffith saying, "I sure do like that kid."

Beyond Griffith showing a sense of humor with a dig at his love for players who came cheap, reality was catching up with him. The previous December, an arbitrator's decision had the effect of gutting the reserve clause, an onerous tool of the owners for nearly one hundred years that bound players to the teams that owned their contracts, even after the contracts expired. With the ruling, players gained the right to play out their options and become free agents. At the end of the 1976 season, reliever Bill Campbell went from the Twins to the Red Sox in this manner.

Before that, the Twins lost another top pitcher, Bert Blyleven, who was also playing out his option and asking for a higher salary than Griffith was willing to pay. Rather than lose him to free agency, the Twins were working out details to trade Blyleven to Texas.

PRELUDE TO PINE TAR

July 24, 2013, marked the thirtieth anniversary of the Pine Tar Game in New York. George Brett of the Kansas City Royals hit a two-run homer with two out in the top of the ninth off the Yankees' Rich "Goose" Gossage to put the Royals ahead 5–4.The Yankees called attention to the amount of pine tar on Brett's bat, compelling plate umpire Tim McClelland to call Brett out and nullify the home run. The Royals' protest of the decision was upheld by the league, Brett's home run was restored and the game was finally resumed and completed on August 18.

The genesis for the idea by the Yankees to challenge Brett's bat goes back nearly eight years to a game at Metropolitan Stadium. Graig Nettles, who played in the Pine Tar Game in New York, was with the Yankees on July 19, 1975. In the top of the first inning, Thurman Munson of the Yankees singled home Roy White.

Minnesota manager Frank Quilici came out and asked plate umpire Art Frantz to check the pine tar on Munson's bat. "I know this is bush," said Quilici, "but I'm desperate." The Twins had the worst record in the American League at the time, and Quilici was looking for any edge he could get. Frantz measured the pine tar on the bat and called Munson out, wiping out the run he had just driven in.

Munson yelled some strong words at Quilici, who later recalled with a laugh, "It was another couple years before Munson would talk to me again."

The gamble paid off as the Twins won the game 2–1.

Graig Nettles didn't forget the event and eight years later tipped off his manager, Billy Martin, to the potential for doing the same thing after he noticed the excessive pine tar on Brett's bat, thus setting off a more-remembered incident at Yankee Stadium.

Even more than thirty-five years later, fans aren't always comfortable with the idea of players having freedom and, as a result, leverage in negotiations. In 1976, the concept was new and not well received in Minnesota.

In his final start with the team, on May 31, Blyleven was booed and serenaded with, "Goodbye, Bert—we're glad to see you go." In response,

Roy Smalley joined the Twins in 1976 and played for his uncle, Gene Mauch. *Minnesota Twins.*

as he walked off the mound in the middle of the ninth, he gave the fans the finger. After the game, Blyleven said he didn't regret the gesture, called the fans frontrunners and said, "Maybe I should flip them every game and that would bring more fans to the park. Maybe that fat [obscene word] Griffith would have some more money to pay us with." The following day, the Twins traded Blyleven to the Rangers for four players, shortstop Roy Smalley being the most significant of them.

In the years when the reserve clause bound players to their teams, Griffith could get away with being tightfisted. With players able to negotiate contracts based on their value in a more open market, teams unable or unwilling to meet those salaries would have difficulty in keeping top players. And so it was with the Twins.

The 1976 Twins led the American League in runs while hitting only eighty-one home runs. However, their offense could barely keep up with their lack of pitching, especially with the departure of Blyleven. Still, the Twins finished 85-77, their best record in six years, and ended up only five games out of first. A surge in the final month brought them closer to the top, but it was too late to attract fans, and the Twins finished last in the league in attendance, the sixth straight year in which they couldn't reach 1 million.

THE LUMBER COMPANY

The Minnesota Vikings had been the main attraction at Met Stadium for many years, and in 1976, a soccer team, the Kicks, came along and drew in fans. Young people flocked to the Met, sometimes filling the stands inside and often filling the parking lot as well. Tailgating, once the domain of

AFTER A PERMANENT GRANDSTAND was erected at Met Stadium in 1965, the distance down the line in left field was 346 feet and 365 to left center; the fence was 12 feet high. In 1975, though, the Twins installed an 8-foot fence in front of the grandstand. Dubbed Robertson's Roost, after Billy Robertson, the director of stadium operations who had come up with the idea, the fence shortened the distances to 330 down the line and 346 to left center. Robertson and the Twins hoped it would increase home runs for a team that hadn't hit that many in the last few years. In addition to bolstering power numbers for the Twins—as well as opponents—the shorter fence provided the excitement of outfielders being able to leap and rob batters of home runs, a sight that was rare at Met Stadium. (Jim Hughes of the Twins pitched two straight shutouts in May 1975, and fans were treated to the sight of left fielder Steve Braun preserving the second one by robbing Milwaukee's Tim Johnson of a home run in the ninth inning of that game.)

But the excitement generated one way or another wasn't enough for the Twins to keep the Roost for a second season. Nevertheless, they again got a shortened porch near the end of the 1976 season because of bleachers that were installed in front of the grandstand for the Minnesota Vikings' first home game. The Vikings went on the road as the Twins came back to the Met for their final four home games. Rather than have the stadium crews take the bleachers down and then put them back, the Twins requested permission from the American League to leave them up. Rules normally prohibited teams from changing fence alignments during the season, but the league granted a dispensation since none of the games involving the Twins and their opponents would have a bearing on first place. In the final four games, players from both teams benefited from home runs into the shortened porch.

Vikings fans, became popular in the summer as well. At Kicks games, many who grilled, drank and threw Frisbees in the parking lot didn't even bother to go in for the game.

In 1977, the Twins joined the act. With a team that got off to a good start and players that produced excitement, baseball was a big thing

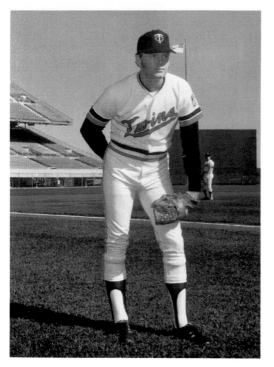

Dave Goltz pitched eight seasons for the Twins and never had a losing record. *Minnesota Twins.*

again. Fans who liked to see runs scored got what they wanted—from both sides.

Minnesota led the American League in runs with a number of intriguing players contributing in different ways. Larry Hisle led the league with 119 RBIs. Lyman Bostock scored 104 runs and had a .336 batting average. Dan Ford, Craig Kusick and Glenn Adams could all connect, but the leader of the lineup that adopted the name Lumber Company was Rod Carew.

Carew, who had already won five batting titles, reached a new level in 1977. He hit fourteen home runs, matching a career high; scored 128 runs and had 239 hits, including sixteen triples; reached base safely nearly 45 percent of the time; and finished with a .388 batting average. His performance got him on the cover of *Sports Illustrated* along with Ted Williams, the last man to hit over .400 in a season, as well as the leagues MVP award.

The pitching staff was led by Dave Goltz, a Minnesota native who won twenty games in 1977. However, the Twins still gave up the third-most runs in the American League.

Another team, the Chicago White Sox, rivaled the Twins in scoring and allowing runs and had its own nickname to reflect its offense: the South Side Hit Men. Richie Zisk, Oscar Gamble and former Twins player Eric Soderholm pounded the fences and drew fans to Comiskey Park. Through the first half of the 1977 season, these two teams rivaled one another in bludgeoning opponents and in fighting for first place in the American League West.

Near the end of June, the Twins and White Sox were in a virtual tie for first as Chicago came to Minnesota for a memorable weekend series. On Friday night, the Twins took an early 5–0 lead, helped by Hisle's three-

OFFICIAL SCORERS AFFECT PLAYERS' statistics as they determine whether a play will be scored a hit or an error. Even when the decision might have little bearing on a player's season averages, scorers can be lobbied, pressured and berated to change a call. When a no-hitter is on the line, the intensity increases.

For many years, official scorers were beat writers for the newspapers that covered the home team. The writers rotated on the scoring duties, picking up a little extra pay, and some also covered and wrote about the same game they were scoring. Because of the inherent and potential conflict of interest—a writer wanting to get post-game comments from a player whose statistics were dependent on his ruling as a scorer—baseball eventually got away from using beat writers as scorers. Before that, however, two Twin Cities writers were on the spot in games pitched by Dave Goltz, and both got a lucky break at the end that got them out of hot water.

In an October 1974 game at Met Stadium, Toby Harrah of the Rangers reached base in the first inning on a grounder that got by Twins third baseman Eric Soderholm. Although it appeared to be a misplay by Soderholm, scorer Bob Fowler of the *Minneapolis Star* gave Harrah a hit. To Fowler's credit, however, he stuck with his call, as it remained the only hit off Dave Goltz until two out in the ninth inning when, to Fowler's relief, Pete Mackanin tripled. In between the two hits, Texas manager Billy Martin reportedly called the Twins dugout to say he would back them should they want to lobby Fowler to change the call. Twins coach Bob Rodgers called Fowler and asked, "Can you change the hit to an error?" Fowler's reply was, "I can, but I won't." Mackanin came to the Twins in a trade in December 1979, and Fowler wrote a column about how Mackanin, with his ninth-inning hit, had saved him five years earlier.

In September 1976, Patrick Reusse faced a similar situation in Minnesota, and the pitcher again was Goltz. Reusse, who was also covering the game for the *St. Paul Pioneer Press*, awarded a hit to the first batter of the game, California's Dave Collins, who reached base on a grounder to first. Goltz was late in covering and dropped Rod Carew's throw. As it remained the only hit for the Angels into the late innings, Reusse started hearing from the crowd and also from Goltz, who relayed a message to the press box to say he should have been charged with an error. Reusse got off the hook with two out in the ninth when Mario Guerrero dropped a single into right-center field. Reusse later wrote, "I love Mario Guerrero. Always have, always will."

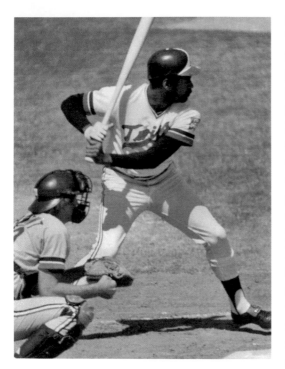

In 1977, Larry Hisle led the American League in RBIs. *Minnesota Twins.*

run, broken-bat home run. The White Sox came back and would have closed the gap even more if not for a gaffe on the bases. With two runners aboard in the third, Ralph Garr hit a drive to right center. Jim Essian, who was on first, held up as he watched Bostock and Ford race for the ball at the fence. Garr also watched and, as he rounded first, passed Essian. The ball cleared the fence, but only two runs scored on the play as Garr was called out for passing a runner. Instead of a three-run homer, Garr had only a two-run single.

The White Sox kept scoring, however, and tied the game in the top of the eighth. Lyman Bostock quickly untied it, leading off the bottom of the inning with a home run, and the Twins won to move into first place. Manager Gene Mauch summed up the way things were going for the Twins, saying after the game, "I've been with a lot of clubs that would gripe and grouse about pitchers losing a five-run lead. Not this club. They simply go back to hitting."

Chicago won the Saturday game before another crowd of more than twenty-one thousand, setting up the rubber game that filled the Met and produced what people were looking for. After the White Sox scored in the first, Adams put the Twins up with a two-run double. Minnesota padded the lead with six runs in the second, capped by a grand slam by Adams, and the White Sox unpadded it with six runs of their own in the third.

The scoring continued, as did the game, even though a drunken fan caused a delay in the fourth by climbing the foul pole in left field. Carew was the big attraction. With many in the stands wearing a promotional jersey with Carew's name and number on it, a giveaway to boost attendance, Carew got four hits, the last one a homer in the eighth, and raised his batting average

to .403. He scored five runs and drove in six, although he was topped in the latter category by Adams, who set a Twins record with eight RBIs. The final score was 19–12 in favor of the Twins, who claimed first place again.

Eventually, the Hit Men and the Lumber Company faded and were overtaken by Kansas City and Texas. The race was entertaining long enough for the Twins to continue drawing fans. It looked like they would reach 1 million in a game against Toronto near the end of August. However, a storm that produced seven inches of rain wiped out the final game of that series. Some streets were still impassable the next night for the opening of a series against Oakland. A crowd of barely 6,300, the smallest of the season up to that point, showed up, but it was enough to put the Twins beyond 1 million fans for the first time since 1970.

Perhaps indicative of how more than the rain could dampen moods, the Twins placed a full-page ad in the *Minneapolis Star* the following day that was supposed to celebrate the attendance achievement. Below a large picture of a smiling Griffith, the text of the ad concluded with, "Twins

Rod Carew with Ted Williams. Williams is the last batter to hit over .400, and Rod Carew pursued that mark in 1977. *Minnesota Twins.*

FAN IN THE STANDS

A feature of Twins home games in the 1960s and '70s was Fan in the Stands, a pre-game radio show hosted by Randy Merriman. Opening with the song "It's a Beautiful Day for a Ballgame," the show took place from the box seats near the Twins dugout with Merriman picking out a few fans for brief interviews. The fans then reached into a "batter's box," a small box from which they could pull a card at random. The card contained the name of one of the players from the roster of the Twins or the visiting team. If that player hit the first home run in the game, the fan would win a prize.

I picked _ALOU_ to hit the FIRST homerun in Metropolitan Stadium on _5/5/71_. If I win, I will receive an RCA Transistor Radio courtesy of Midwest Federal and the RCA and Whirlpool dealers. I understand that my player <u>must</u> hit the FIRST home-run in the game to win a radio for me.
P.S. HE DID IT! PLEASE SEND MY RADIO!
NAME_____
ADDRESS_____
CITY_____

I picked _Clarke_ to hit the FIRST homerun in Metropolitan Stadium on _5/9/72_. If I win, I will receive an RCA Transistor Radio courtesy of Midwest Federal and the RCA and Whirlpool dealers. I understand that my player <u>must</u> hit the FIRST home-run in the game to win a radio for me.
P.S. HE DID IT! PLEASE SEND MY RADIO!
NAME_____
ADDRESS_____
CITY_____

Fan in the Stands cards. Neither of the players picked (Felipe Alou and Horace Clarke) homered in the designated game. *Author's collection.*

Cities, welcome back to the Bigs." Many fans thought it was the team, not the area, that had been absent from the "bigs" in recent years and reacted with displeasure.

The other downer was the contract status of Bostock and Hisle. Both would be free agents at the end of the year, and some of the unsavory exchanges between the players and Griffith in negotiations had made it into the papers. As fans cheered their performances, they also realized that each

hit, each home run and each RBI were putting Hisle and Bostock into a salary strata that Griffith would probably not go for. And he didn't.

After the season, Hisle signed with the Milwaukee Brewers and Bostock with the California Angels. Newcomers Hosken Powell and Jesus "Bombo" Rivera were not going to produce wins or fans the way the departed pair had. The Twins dropped in the standings and in attendance in 1978, and the angst related to free agency increased.

Carew led the league in batting average again (the last time he would do so), but he would be able to play out his option in 1979. It was clear that Griffith would probably trade Carew rather than let him become a free agent. Any chance that the Twins and Carew could agree on a new contract that would keep him in Minnesota was damaged near the end of the 1978 season when word got out about a speech Griffith had given to a Lions club in southern Minnesota. Among his many eye-opening remarks were ones regarding race and the reasons for coming to Minnesota. Nick Coleman of the *Minneapolis Tribune* quoted Griffith as saying, "I'll tell you why we came to Minnesota. It was when I found out you only had 15,000 blacks here. Black people don't go to ball games, but they'll fill up a rassling ring and put up such a chant it'll scare you to death. We came here because you've got good, hardworking white people here."

As appalling as the comments were, Griffith had been known for outrageous remarks, and some contended that what he said wasn't a true reflection of his attitudes. Carew himself, in an autobiography he wrote with Ira Berkow a year later, noted the support he had received from Griffith as he was trying to make the team in 1967. However, there was no way to excuse the harshness of the words, and Carew (as well as many others) was outraged. He was traded to the California Angels before the start of the next season.

Even without Carew, the Twins did better in 1979. One of the players obtained in the Carew trade, Ken Landreaux, produced, and another trade brought left-hander Jerry Koosman. A Minnesota native who had been part of the "Miracle Mets" in

Calvin Griffith. *Minnesota Twins.*

A Minnesota native, Jerry Koosman came to the Twins in 1979 and won twenty games. *Minnesota Twins.*

1969, Koosman won twenty games in his first year for the Twins. Roy Smalley hit twenty-four home runs, John Castino was good enough with the glove at third base to tie for the Rookie of the Year Award and reliever Mike Marshall set a league record by appearing in ninety games. Minnesota finished fourth but kept the race interesting enough to draw more than 1 million fans.

The Twins then languished in what would be their final two seasons at Met Stadium. Mauch had had enough and resigned as manager in 1980. John Goryl took over but didn't last long. He was fired early in the 1981 season and replaced by Billy Gardner.

Minnesota found itself in a race for first in September 1981, but not because it had a great—or even good—team. A strike by the players shut down the season in the middle of the year; when it resumed in mid-August, baseball decided to go with a split-season format. The teams in first place when the season was stopped in June were declared first-half winners, who would play against the second-half champions for the division title at the end of the year. With no team in the American League West taking charge, the Twins still had a chance and were even granted permission to print World Series tickets.

Those tickets weren't needed. Minnesota was officially eliminated from the race on September 30 in what was also the final baseball game played at Metropolitan Stadium.

A 24-29 second-half record (41-68 overall) showed how far the Twins had fallen. A few newcomers provided some highlights, though. Kent Hrbek and Tim Laudner, both from the Twin Cities area, debuted and hit home runs in their first games. Another, Gary Gaetti, joined the team in September and homered in his first plate appearance. The three had an impressive start and would be key members of the Twins as they looked ahead to a new era in a new home.

INSIDE BASEBALL

SEARCHING FOR A STADIUM

The rise of the Minnesota Vikings brought the first hunt for a new stadium in the Twin Cities in the 1970s. When the Twins came to Minnesota in 1961, many of the classic stadiums (from a period starting in 1909) were still in use in the majors. Along with newer stadiums either built or converted to major-league use, these structures were built for baseball. A gridiron could be wedged in to accommodate football, but the configuration and seating was definitely second-class for that sport. The limited seating capacity was another problem in some stadiums.

Some of the classic ballparks were phased out in the 1960s as cities went to multipurpose facilities that treated the two sports equally. Minnesota was still using a stadium that was good for baseball but horrible for football. The construction of a double-decked grandstand in left field helped as it put more seats in good viewing position for football, but the gridiron itself was a long distance from the majority of seats.

As the Vikings went to the Super Bowl after the 1969 season and continued to win division titles, the push in the area was to meet their needs. A plan for a grandiose domed football stadium in downtown Minneapolis was talked about but not fulfilled.

Something had to be done for the Vikings. By this time, the Twins wanted in, too. The lack of fans at Met Stadium in the 1970s was because of the

The Twins moved indoors to the Metrodome in 1982. *Minnesota Twins.*

dreariness of the team, but Calvin Griffith was also unhappy with the stadium. When the Twins arrived in Minnesota in 1961, Met Stadium was expanded with an extension of two decks along the right-field line. A similar extension never happened on the left-field side. The grandstand ended at the third-base dugout. Seats consisting of folding chairs were in place beyond

that, and wooden bleachers (just a board to sit on with no seat back) were located above the folding chairs.

Through 1976, the wooden bleacher seats were sold for the $1.50 general admission price. It was a good deal for fans, who could buy the cheapest ticket without being stuck beyond the outfield fences, but it was lost revenue to Griffith. The folding chairs, sold at a higher price as reserved seats, were often empty as fans went with a cheaper ticket and sat a little farther back. (Many people, especially as crowds dwindled in the 1970s, bought the cheapest ticket and ambled into the grandstand, often plopping into box seats with no resistance from ushers. Many also snuck in their own beer or stronger refreshments.)

In 1977, Griffith finally corralled those with general admission tickets into the outfield and set up a checkpoint to keep them out of the more expensive seats. In part, it was his way of indicating displeasure with the lack of a permanent grandstand beyond third base. Also in 1977, the Minnesota legislature passed a bill for a new stadium or stadiums for the Vikings and Twins. Known as the no-site stadium bill, it didn't designate a location in the Twin Cities. On the table was a remodeling of the Met for the Twins, along with a new adjacent football stadium or a multipurpose stadium to be used by both teams. In addition, an open-air stadium or one with a dome was to be considered. Revenue bonds would pay for the facilities, and a liquor tax for the metropolitan area was included in the bill as a backup for the bond revenues.

A new stadium commission spent its first year and a half considering the options, eliminating some and leaving itself with a choice of Bloomington and Minneapolis. Not all Minneapolis residents were in favor of their city getting the nod, but opposition to the state's largest city was even stronger elsewhere. St. Paul, as usual, was against Minneapolis as the site. Bloomington, not surprisingly, didn't want to lose the major-league teams that the city had come to see as its own.

Minneapolis business interests and civic leaders had a different view. It had been Minneapolis behind the building of Met Stadium. Over the years, as money was needed to expand and maintain the ballpark, it had been Minneapolis, not Bloomington, that came through. Labor leader David Roe, in an interview with Amy Klobuchar for *Uncovering the Dome*, said, "Minneapolis figured that eventually Bloomington would contribute to the stadium's upkeep. But instead of contributing money, they asked for more." Klobuchar added that the attitude in Minneapolis was, "Why should we use the city's money to subsidize a hot-shot, ungrateful ex–cow town?"

The metro-wide liquor tax to guarantee the bond repayment for the stadium was no more popular than most taxes, but it wasn't until the stadium commission selected Minneapolis as the site that there was strong opposition to it. Much of it came from legislators from St. Paul and Bloomington, who were derided as sore losers, although a state senator from Faribault, who had voted for the stadium when it was a no-site bill, voted to repeal the liquor tax. He candidly noted that had Bloomington been selected as the stadium site, he would have had no objection to the tax.

Sore losers or otherwise, opponents of the liquor tax prevailed. That didn't stop a new tax on hotels and liquor from being adopted for Minneapolis only, but that action didn't end the opposition to the stadium, either. As the fight continued, to the consternation of opponents, construction for a multipurpose domed stadium began on the site in Minneapolis, known as Industry Square, in late 1979.

The stadium commission parried the thrusts while complying with (and perhaps, at time, dodging) the strict requirements of the law. One was to get thirty-year leases signed by the Vikings and Twins before the bonds could be sold. The Vikings were no problem. However, the commission was well along in many aspects of the project before getting the Twins to sign. By this time, Calvin Griffith was able to hold out and get an escape clause, which would allow him out of the lease if certain conditions, most relating to attendance at Twins game, weren't met. The less-than-ironclad lease with the Twins created a number of challenges for the commission starting soon after the Metrodome opened.

Construction continued, and the roof of the Metrodome was inflated in early October 1981. A little more than six weeks later, it came down under the weight of ten inches of snow. Opponents of the domed stadium had a few days to crow before it was reinflated. Over the next few years, the dome collapsed again and drew inordinate amounts of news coverage. However, for more than twenty-nine years after the initial inflation, any collapse of the roof was quickly remedied. Games went on as scheduled. (For many years, a postponement of a Twins game in April 1983 was attributed to the collapse of the roof. However, the snowstorm that caused the collapse kept residents at home and the visiting team from arriving in the Twin Cities. The decision to postpone the game, a result of the paralyzing effect of the storm, was made ten hours before the roof collapsed that evening. Overnight the dome was inflated, and baseball was on again for the following night.)

THE METRODOME OPENS

The Hubert H. Humphrey Metrodome (the name was chosen to honor Humphrey at a time when the former vice president and longtime Minnesota senator was dying) opened with an exhibition game between the Twins and Philadelphia Phillies on Saturday night, April 3, 1982. The weather was ideal for an indoor game—an outside temperature of nineteen degrees with strong winds and a bit of sleet mixed in. More than twenty-five thousand fans attended. Kent Hrbek started the scoring with a two-run homer in the fourth off Mike Krukow and later added a solo home run off Sparky Lyle. Pete Redfern threw the first pitch in the new stadium and, one batter later, gave up the first hit, to Pete Rose. Although this was an exhibition game, the names of the players who delivered the first hit and first home run, because of their prominence, are better remembered than the player who got both in the first regular-season game three nights later.

That player was Dave Engle, who homered to left with two out in the first. Engle played right field in the official opener, but it was soon discovered that he had trouble seeing fly balls against the backdrop of the Metrodome roof. He wasn't the only one with that problem, but Engle's was the result of damage to one of his pupils from a childhood accident. Because of his sight problems indoors, he was later moved to catcher.

Before a sellout crowd, the Twins lost 11–7 to Seattle in the first regular-season game despite two home runs by Gary Gaetti, who also was thrown out at home trying for an inside-the-park homer. Gaetti, along with Hrbek and Laudner, the players who had broken in with home runs the previous year, were part of a young group of players who would stay together for many years.

Gary Gaetti homered in his first time up in the majors in 1981. He hit two home runs in the first regular-season game in the Metrodome in 1982. *Minnesota Twins.*

Tom Brunansky joined the Twins in a mid-May trade, which

Kent Hrbek grew up near Met Stadium and played his entire major-league career (1981–94) for the Twins. *Minnesota Twins.*

was controversial because it came at the same time the Twins were trading veteran catcher Butch Wynegar to the Yankees and a month after they had traded Roy Smalley to New York. Griffith was blasted for dumping players with higher salaries for rookies and minor-leaguers, although many of the young players, including Brunansky, turned out to be good acquisitions.

A month later, left-hander Frank Viola made his major-league debut with the Twins. This collection of young players didn't lead to a lot of wins, but many fans look back fondly on that season as the one in which the Twins began to develop a crew that would later lead them to the top.

The first half of the 1982 season was disastrous for the Twins. Even by playing close to .500 during the second half, the Twins finished with their worst record ever—60-102, also the worst record in baseball.

The Twins were also last in the American League in attendance. Helped by a sellout for the opener and an overall curiosity or desire by people to see the Metrodome, those enticements were offset by a bad team and no air conditioning that first year. No one had made a decision not to put in air conditioning; the ductwork was there for it, if needed, and the builders wanted to see if it was necessary. Another stadium with an air-supported roof, used by the Detroit Lions of the National Football League in Pontiac, Michigan, reportedly had inside temperatures ten degrees cooler than outside. Of course, a football team plays most of its games in cooler months. What

would the conditions be inside the Metrodome in June, July and August? The answer was hot and humid.

The air conditioning was installed and first used on June 28, 1983, a night when the game-time temperature outside was only sixty-five degrees (three degrees cooler than the temperature inside). But there were also plenty of hot days and nights (not to mention rain that would have otherwise postponed or delayed games) when the climate control in the Metrodome was welcomed by many.

The flip side of having a domed stadium was that many sunny days and comfortable nights, when sitting outdoors would have been ideal, were lost. The Metrodome was built before the technology for a retractable roof was feasible or at least affordable. It was also built at the tail end of a period of multipurpose stadiums. In the 1960s, as professional football became more significant, communities built stadiums that could handle both baseball and football rather than having the latter wedge a gridiron into stadiums designed for the former. Ten years after the Metrodome opened, the trend was toward separate stadiums for baseball and football teams.

The Metrodome was indeed functional. It was home to the Twins and Vikings, as well as the Minnesota Gophers football team. It hosted college basketball tournaments and, for one season, the Minnesota Timberwolves of the National Basketball Association. Wrestling matches, monster-truck shows, concerts, trade shows and high school and college sports were all frequent attractions. The Metrodome offered a place for downtown workers to walk and run during the day and for rollerbladers to cruise through the concourses in the evening and on weekends in the winter.

But what the Metrodome wasn't was charming. A domed and/or multipurpose stadium doesn't have to be barren. The first domed stadium, the Astrodome in Houston, was dubbed the "Eighth Wonder of the World" when it opened in 1965, in part because of the luxurious nature of its suites and private areas. The Metrodome, facing as much opposition as it had, was forced to have a strict budget that made it difficult to include amenities.

Especially in the Metrodome, the unique features associated with baseball parks were lost. And what was unique wasn't desirable. Bad hops and fly balls that outfielders lost sight of in the roof quickly became associated with the stadium. Tom Brunansky hit the Metrodome's first inside-the-park home run in May 1982 after New York left fielder Lou Piniella lost the ball in the darkness of the roof. The ball landed well behind Piniella on the warning track, and the only surprising part of the play might have been that, off the spongy turf, it didn't bounce into the seats for an automatic double. Instead,

LONG ONES—DISTANCE

Harmon Killebrew's first home run as a member of the Twins, on April 30, 1961, hit the batter's eye in center field at Metropolitan Stadium and was estimated to be 450 feet. These estimates were really just rough guesses provided by public relations director Herb Heft and his assistant, Tom Mee.

Within a few years, the measurements were more precise. Len Meffert, the educational director at the prison in Stillwater, drew up an insurance-like table log measuring the distance to fences and used angles and correlated lines to determine the exact distance to each section and row in the outfield. The distances determined at the Met were based on the point of impact, not on where the ball would have landed. Thus, fans were underwhelmed when Killebrew's blast into the upper deck in left field on June 3, 1967, was measured at only 434 feet. However, the next day, an estimate of 520 feet was announced as the distance the drive would have traveled, and that

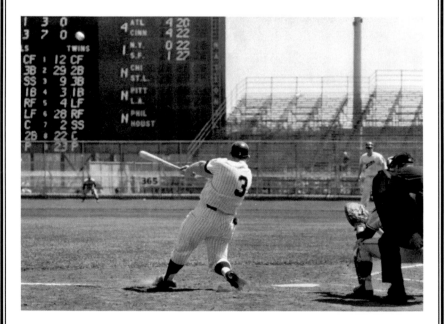

Harmon Killebrew hits a home run into the upper deck in left field on June 3, 1967. *Minnesota Twins.*

figure remains as the longest for any home run ever hit by or against the Twins in Minnesota.

After the Twins left Met Stadium, a graduate student at the University of Minnesota, Peter Swenson, constructed a pair of charts to show distances from home plate to all parts of the outfield at the Metrodome. These charts also allowed for the trajectory of the drive to determine where it would have landed on a flat plane. Even though all home run distances at the Metrodome were estimates on how far the ball would have traveled, no one was able to approach Killebrew's feat. Ben Oglivie of the Milwaukee Brewers came the closest with a home run into the upper deck in right center in July 1983 with the distance estimated at 481 feet.

LONG ONES—LENGTH

The Minnesota Twins have twice hosted a twenty-two-inning game. The first began on Friday night, May 13, 1972. After Milwaukee scored twice in the top of the seventh to tie it, the game remained scoreless the rest of the night and into the following morning. Many fans, who planned to arise early for the fishing opener on Saturday, left, but plenty remained, only to be frustrated when the game was suspended because of a 1:00 a.m. league curfew after twenty-one innings.

When the game resumed that afternoon, the starters for the regularly scheduled game, Jim Lonborg of Milwaukee and Bert Blyleven of Minnesota, relieved in the twenty-second inning. Milwaukee didn't take long to push across a run off Blyleven and then withstood a rally by the Twins in the bottom of the inning for a 4–3 win. At least the Twins won the other game played that day—although it took them fifteen innings to do it, forcing the teams to play back-to-back games that lasted a total of thirty-seven innings.

On August 31, 1993, the Twins trailed Cleveland by a run with two out in the bottom of the ninth when consecutive doubles by David McCarty and Terry Jorgensen sent the game into extra innings—many extra innings. Finally, Pedro Munoz homered in the last of the twenty-second to end the game. Although the Twins had only tied their record for innings played, they set a new team record for longest game time as the contest lasted six hours and seventeen minutes.

it caromed off the fence and stayed in play, and Brunansky came all the way around without having to slide at home. Two years later, the Twins trailed the Chicago White Sox 2–0 and had two on and one out in the ninth. Tim Teufel dropped a hit into right. Harold Baines trotted in and then suddenly leaped and made an unsuccessful stab at the ball, which had hit a depressed spot in the turf and taken a high hop. By the time Chicago could chase down the ball and get it back in, Teufel had a three-run, game-winning homer. White Sox manager Tony LaRussa called it "a disgrace to baseball."

The 1984 season started with rumors about the possibility of the Twins moving to the Tampa-St. Petersburg area in Florida. After two seasons of drawing fewer than 1 million fans, the team was looking at the possibility of exercising its escape clause from the Metrodome lease. The situation got comical in May as a buyout of unsold game tickets was organized by local business leaders. One weekday game in May, when the tickets were discounted, was a near sellout even though fewer than nine thousand seats were occupied.

Kirby Puckett broke in with the Twins in 1984 with four hits. *Minnesota Twins.*

The idea behind the buyout was to get the paid, if not actual, attendance to a point that Griffith wouldn't be able to get out of the lease. Griffith said artificial ticket sales shouldn't keep him from using the attendance clause in the lease and leaving Minnesota. What might have happened in the courts if this legal question were pressed became moot when Griffith instead sold the Twins to banker Carl Pohlad.

Around the time this comedic drama was playing itself out, the Twins called up a new center fielder, Kirby Puckett, who quickly became a fan favorite. Along with players such as Gaetti, Brunansky, Laudner and Viola, a group that could still be called youngsters but were now looking like veterans, the Twins were also playing better baseball.

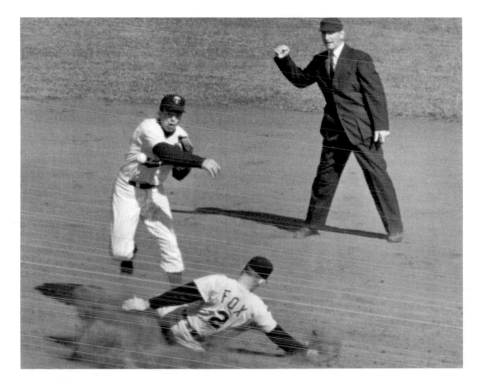

Billy Gardner, pictured here throwing over Chicago's Nellie Fox, was an infielder for the Twins in 1961 and later became their manager. *Minnesota Twins.*

Never more than four and a half games out of first during the season, Minnesota nosed into the top spot for a few days in May, made its move in late July and opened up a lead of five and a half games in late August. Real crowds and actual fans began turning out. The Twins wrapped up their home season in a tie for first with Kansas City, but a disastrous final week on the road, including a loss at Cleveland after holding a 10–0 lead, dropped Minnesota to a tie for second. After the past few seasons, a pennant race was a welcome change, and the Twins had expectations to contend again.

It didn't happen in 1985, however. After having their hopes dashed, the Twins fired Gardner as manager and brought in Ray Miller, a longtime pitching coach for Baltimore, as the new skipper. The season also marked the return of Roy Smalley in a pre-season deal with the White Sox and Bert Blyleven, nine years after his flipping farewell, in an August trade with Cleveland. The team showed more power with Gaetti hitting thirty-four home runs and Puckett, who had hit only four in his initial seasons with the teams, hitting thirty-one.

ALL STAR EVENTS

The big event of 1985 was the All Star Game at the Metrodome. By this time, the stadium commission had installed lights to illuminate the roof, a problem that helped cut down on outfielders losing sight of fly balls, and this spectacle was avoided in the All Star Game. However, another quirk, the turf, was on display in the third inning as American League center fielder Rickey Henderson, fearful of the ball bouncing over his head, played back on a hit that bounced in front of him, allowing Dale Murphy to leg out a double.

Other than that, the All Star Game was mostly uneventful, for better and worse. The National League won 6–1 in a game that lacked the excitement of the previous one in Minnesota, played in 1965. Both managers in the 1985 game, Dick Williams and Sparky Anderson, are in the Hall of Fame, as are fifteen players, including Rickey Henderson, Ryne Sandberg, Nolan Ryan and Cal Ripken. Not included in that group is Pete Rose, who was later banned from baseball and, as a result, ineligible for the Hall of Fame. Rose was the only player who appeared in both the 1965 and 1985 All Star Game.

The Twins had only one player in the game, Tom Brunansky, who had helped the American League win the first home run hitting contest held as part of All Star events. More than forty-six thousand fans attended workouts held the day before the game, with the Home Run Derby as the climax. Each league had five batters, and each could hit in each inning until he made five

Tom Brunansky was a power-hitting outfielder for the Twins during the 1980s. *Minnesota Twins.*

outs (with anything but a home run counting as an out). It being the first such contest, no one knew how long the event would last; scheduled to be three innings, it was cut back to two because of the length. Brunansky came up with the American League trailing 16–14 in the bottom of the second and hit three home runs in four swings to win it for his squad.

Each league lost a homer in a strange way. Eddie Murray of the American League hit a high fly that seemed destined for the seats when it hit one of the speakers hanging from the roof. The National League's Ryne Sandberg got robbed of a home run when one of the high school students shagging fly balls leaped and caught one of his drives before it cleared the fence.

The event was confusing in some ways. The scoreboard didn't have the number of outs posted, so fans weren't sure how many each player had remaining. Also, each player got two practice swings his first time up, and it wasn't clear what counted and what didn't. Nevertheless, those in attendance had a good time, as did another group of about four hundred people that morning at another confusing event.

SARTORIAL SNAFUS

In 1985, Lou Whitaker of the Detroit Tigers forgot to bring his uniform to the All Star Game. He borrowed some apparel from the Twins, got a Tigers jersey from the concession stand and had a "1" drawn on the back with a black marker. Applying a number to the back was the best he could do, and he was the only one of the Detroit players in the game without his name on his uniform.

Willie Mays and Juan Marichal of the San Francisco Giants almost had the same problem in the 1965 All Star Game. The Giants had mistakenly sent their uniforms and equipment back to San Francisco from Philadelphia, where the Giants had last played. The original plan was for the pair to wear Twins road uniforms turned inside out, but someone was able to get the San Francisco uniforms to Minnesota in time. Mays's helmets didn't make it, however. He hit his leadoff home run wearing a Cubs helmet, courtesy of Billy Williams, and later used Johnny Edwards's Reds helmet.

Honorary captains Sandy Koufax and Harmon Killebrew were brought to Boom Island in northeast Minneapolis for what was to be a photo

opportunity. Neither realized the event had been publicized and that Koufax was to pitch to Killebrew, who would try to hit the ball across the Mississippi River (about seven hundred feet). Koufax seemed bewildered and Killebrew angry about the poor organization, although Killebrew was still a good sport and fungoed a few balls into the river.

The Twins finished 77-85 in 1985, and their record got even worse in 1986. With the team in last place with a little over three weeks to go in the season, Miller was fired and third-base coach Tom Kelly was named interim manager. Minnesota had a 71-91 record in 1986 and a lot of issues to resolve. Going into 1987, season ticket sales were down, a reflection of the lack of excitement and expectations fans had for the Twins.

CHAPTER 5

CHAMPIONSHIP RUNS

ALL THE WAY IN 1987

Front office shuffling and the search for a manager were the main topics of Twins news after the 1986 season. Jim Frey, who had managed the Royals and Cubs in the 1980s, turned down the managing job, and a number of other names were reported or at least rumored, including Chuck Cottier and Joe Torre. A few days after Frey declined Minnesota's offer, the team decided to stick with Tom Kelly, who had taken over in an interim role near the end of the previous season. At the same time, Andy MacPhail, who had been in charge of the search for a manager, was named vice-president of baseball operations (known as general manager in the less-corporate days of baseball).

Relief pitching had been a problem for the Twins over the past couple seasons, and MacPhail upgraded the bullpen with a trade for Jeff Reardon and the free-agent signing of Juan Berenguer. Along with Keith Atherton, Berenguer helped hold leads in the later innings to get to Reardon to the ninth, and the new closer produced thirty-one saves in 1987. Another notable acquisition before the season started was outfielder Dan Gladden.

The Twins still had a strong group of everyday players. Gaetti, Hrbek, Laudner, Puckett and Brunansky went back at least several years with the team. Greg Gagne and Steve Lombardozzi would be starting their second season together as the middle-infield combination.

Greg Gagne was the starting shortstop on both championship teams. *Minnesota Twins.*

On the mound, Viola and Blyleven led the starters, but there was a drop off in effectiveness after that.

The Twins weren't a great team in 1987, but they were good enough to survive a division that lacked a dominant team. What happened that year wasn't expected, and it took a while for fans to get used to the idea of a championship as a possibility.

Minnesota was strong enough at home (winning fifty-six of eighty-one regular-season games and all of its games in the Metrodome in the playoffs and World Series) to overcome problems on the road. The team was outscored 806–786 during the regular season, a differential that computes to seventy-nine expected wins, but the Twins were able to win eighty-five games, enough for a division title.

In 1987, the dominant teams in the American League were in the East Division, as were the doormats. With the league playing a balanced schedule (as opposed to playing teams within the division more than those from the other divisions), Detroit and Toronto led the East with ninety-eight and ninety-six wins, respectively. Milwaukee and New York also had more wins than the Twins. At the other end of that division, Baltimore and Cleveland had fewer than seventy wins.

The West Division was more even, with the win totals among seven teams ranging between seventy-five and eighty-seven. Thus, the battle for first place was up for grabs, and the Twins starting snatching near the end of May. Minnesota tied for first on June 9 and didn't fall behind again.

With a record of 49-40 at the All Star break, the Twins held a two-game lead over Oakland and Kansas City. Even though Minnesota lost more games than it won the rest of the way, it had the top spot to itself except for a few days in August when the Athletics worked their way up to a first-place tie.

The Twins moved in front again and steadily built a gap in September, finally clinching the title with six days left in the season.

In the East, the Tigers and Blue Jays battled to the final weekend, with the Tigers finally emerging as the champions and producing the best record in the majors.

Regardless of how optimistic Twins fans were of the team's chances in the post-season, they were excited at being in the playoffs for the first time in seventeen years. The Metrodome was full and frantic as the league championship series opened.

Tom Kelly managed the Twins to world titles in 1987 and 1991. *Minnesota Twins.*

Doyle Alexander, who was 9-0 after coming to the Tigers in an August trade, started for Detroit against Frank Viola in what became an entertaining back-and-forth game to open the playoffs. Gaetti started the scoring with a home run in the last of the second, and Mike Heath tied it for Detroit with a homer the following inning.

Gaetti untied the game again with a home run to lead off the fifth, and the Twins scored two more in the inning. Detroit came back with runs in the sixth and seventh and went ahead 5–4 with a pair of sacrifice flies in the eighth. In the bottom of the inning, Puckett doubled home Gladden and later scored the go-ahead run on a single by Don Baylor. Brunansky doubled home two runs, and the Twins went on to an 8–5 win.

After getting past Alexander, the Twins next faced Jack Morris, a native of St. Paul whom the Twins had never beaten in Minnesota. The Tigers scored two in the second off Blyleven, but the Twins got doubles by Gaetti, Brunansky and Laudner (with a walk by Gagne in between) to take a lead they didn't give up.

The best-of-seven series then moved to Detroit. The Twins overcame a 5–0 deficit and had a 6–5 lead into the last of the eighth, only to lose as Pat Sheridan hit a two-run homer off Reardon.

The following night, the Twins had a 4–3 lead in the sixth, but the Tigers had runners on second and third with one out when Laudner, in one of the

HARMON KILLEBREW, KIRBY PUCKETT, Dave Winfield, Paul Molitor, Bert Blyleven and Rod Carew are among the Minnesota Twins who have been inducted into the Hall of Fame. Another Twins player has a plaque in Cooperstown, although he is usually not associated with Minnesota. Steve Carlton is one of the best left-handed pitchers in history, and he won four Cy Young awards in the National League between 1972 and 1982.

Carlton came to the American League in his waning years but still had not pitched in Minnesota until the Twins got him in a trade from Cleveland in late July 1987. He was hit hard in his debut with the team on August 4 but did better four days later against the Oakland Athletics in his first game in the Metrodome. Lefty had one good game left, and he held the A's to three hits and no runs through eight innings as his team built a 9–0 lead. However, he wasn't able to finish, and after four hits, a walk and two runs, Carlton gave way to a reliever with two out.

Carlton struggled through the rest of the season and wasn't on the post-season roster, but he was back in 1988. He was given a start on April 23 against Cleveland but knocked out in the sixth inning. Carlton's walk off the mound also marked the end of his major-league career.

So anonymous has been Carlton in Twins history that when the team visited the White House after winning the 1987 World Series, the caption under a picture of players with President Ronald Reagan on the front page of the October 30, 1987 *St. Paul Pioneer Press Dispatch* listed Carlton an "unidentified Secret Service agent in dark glasses."

His time with the Twins wasn't indicative of his Hall of Fame career, but Carlton did give local fans the chance to see his 329th and final win. Carlton is one of two pitchers in the 300-win club to win his final game in Minnesota. (Tom Seaver, pitching for the Boston Red Sox, won his 309th and final career game at the Metrodome on August 18, 1986.)

key plays of the series, picked Darrell Evans off third base. Minnesota won and was up 3-1 in the series. The Twins wrapped it up the next afternoon in Detroit and then flew home to a celebration at the Metrodome, packed with screaming fans waving homer hankies.

The success continued in the first two games of the World Series against the St. Louis Cardinals. Viola pitched a strong game, and the Twins scored seven runs in the fourth inning—Gladden's grand slam the big blow—for a 10–1 win. The following night, Gaetti and Laudner backed Blyleven with home runs in an 8–4 win.

However, the Cardinals won all three games played in St. Louis, and the Twins were facing elimination as they came back home for the sixth game of the series. St. Louis left-hander John Tudor carried a 5–2 lead into the bottom of the fifth, but he didn't retire another batter. Puckett singled and scored on a double by Gaetti. Baylor then homered to left to tie the score, and later in the inning, Lombardozzi singled home Brunansky for the lead. The following inning, Hrbek added a grand slam, and the Twins tied the series with an 11–5 win.

Viola took the mound against rookie Joe Magrane in the final game. The Cardinals took a 2–0 lead, but the Twins came back with runs in the second and fifth to tie the game.

Brunansky, Hrbek and Roy Smalley walked to load the bases with one out in the sixth. Gladden struck out, but Gagne pulled a grounder down the line to third. Tom Lawless dived and gloved the ball, but his throw to first wasn't in time to get Gagne, and Brunansky scored to put the Twins ahead.

Minnesota added a run in the eighth, and then Reardon entered in relief of Viola. He retired Tom Herr, Curt Ford and Willie McGee, who grounded out to Gaetti, setting off a celebration in the Metrodome and beyond.

For the first time since moving to Minnesota, the Twins had won the World Series. It was the first major-league championship for a Minnesota team since the Minneapolis Lakers had won the National Basketball Association title in 1954.

An unexpected event, nearly unthinkable at the start of the season, had occurred: the Twins were world champions.

IN-BETWEEN SEASONS

The excitement of the world title carried on through a raucous parade in the Twin Cities, continuing sales of sweatshirts and other merchandise commemorating the championship and into 1988. Season ticket sales surged, and the Twins set a new American League attendance record.

Frank Viola was the World Series MVP in 1987 and then won twenty-four games and the Cy Young Award in 1988. *Minnesota Twins.*

On the field, the Twins struggled as defending champions while Oakland, one of the pursuers the year before, won twenty-four of its first thirty-one games. The Twins were twelve games behind Oakland and in last place on May 9. After that, the two teams posted nearly identical records, and the Twins got as close as three games to first place in mid-July. However, the poor start for Minnesota was too much to overcome, and the Twins finished thirteen games out of the lead, though they did win six games more than they had the previous year.

Brunansky was traded to St. Louis in the first month of the 1988 season, the start of a breakup of the players who had carried them through the 1980s. Hrbek and Gaetti had solid seasons but also missed time with injuries. Puckett, though, had his best year, batting .356 with twenty-four home runs, 121 RBIs and a league-leading 234 hits. Viola was even better, winning twenty-four games with an ERA of 2.64 and receiving the Cy Young Award, only the second Twins pitcher to win it.

By the time the 1989 season started, Viola was in a dispute with the team over a contract extension. It eventually was settled, but soon after, Minnesota traded Viola to the New York Mets for five pitchers. Pitching, even during the time Viola was with them, was a problem for the Twins, who slumped into fourth place.

The team got worse in 1990, falling to the bottom of the standings and staying there. Some bright spots included two of the pitchers the Twins had received in exchange for Viola. Kevin Tapani led the Twins in wins, and Rick Aguilera was effective as a closer, getting thirty-two saves. Scott Erickson, at the age of twenty-two, was called up from the minors in June and won eight games; in September, Erickson had a 5-0 record with a 1.35 ERA.

As had been the case after the 1989 season, few expected much from the Twins the following year.

ENCORE CHAMPIONSHIP

In 1965, 1969 and 1987, the Twins had finished first after a disappointing season. After a last-place finish in 1990, Minnesota didn't have high hopes in 1991—neither did the Atlanta Braves, who had also ended up in the cellar the year before in the National League West Division. But these teams would meet in October.

The Twins started the 1991 season poorly, losing ten of their first fourteen games. Near the end of May, they were seven and a half games out of first. On June 1, though, Minnesota began a fifteen-game winning streak. The final game in that streak put the Twins into first, a spot they held for much of the rest of the season.

Scott Erickson, in his first full season, led the charge over the first half of the year. After losing his first two starts, Erickson won twelve consecutive decisions, three of them shutouts. His ERA at the end of his winning streak was 1.39. Arm problems slowed Erickson down, but he still managed to win twenty games that season.

Jack Morris also contributed on the mound. The Minnesota native had been a free agent after the 1986 season and had talked to the Twins, although collusion among the owners was in effect at the time, and Morris remained in Detroit. Four years later, he finally joined the Twins and won eighteen games. Two pitchers from the Viola trade had good years as Kevin Tapani had sixteen wins and Rick Aguilera forty-two saves.

Gary Gaetti was gone, but the Twins still had Hrbek, Puckett, Gladden and Laudner, among others, from the 1987

Rick Aguilera came to the Twins in a 1989 trade for Frank Viola and became the team's bullpen ace. *Minnesota Twins.*

Chuck Knoblauch was the American League's Rookie of the Year in 1991.
Minnesota Twins.

champions. In addition, two newcomers contributed. Chuck Knoblauch was great at second base and was named the American League Rookie of the Year. Chili Davis, a free-agent acquisition, was the designated hitter and led the team with twenty-nine home runs and ninety-three RBIs.

Minnesota won ninety-five games, the most in the American League, and won the West by eight games. Against Toronto in the league playoffs, the Twins split the first two games, played at home. The third game of the series, in Toronto, went into extra innings, and the Twins won it when Mike Pagliarulo homered in the tenth.

Wins in the next two games put the Twins in the World Series for the second time in five seasons. In the National League, Atlanta was the surprise team. The Braves had put up the worst record in the majors the previous year. They did better in 1991, playing close to .500 for the first half of the season, but they were well out of contention. Atlanta won fifty-three of eighty-one games during the second half, clinched the division title on the next-to-last day of the regular season and then beat Pittsburgh in the playoffs for the pennant.

A matchup between two teams that had gone from last to first produced one of the most exciting World Series ever. Opening at home, Minnesota took a 4–0 lead in the first game and would have had more had it not been for Atlanta catcher Greg Olson, a Twin Cities native who had played for the Minnesota Gophers and then briefly for the Twins. With three runs already across in the last of the fifth, the Twins had the bases loaded with one out. Gladden then tried to score from third on a fly ball to left. Olson blocked the plate, tagged Gladden and held on to the ball despite being bowled over. The play represented the hard-nosed style of both Gladden and Olson. A photo of an upended Olson, on his head and forearm with the ball in his

glove, made the cover of *Sports Illustrated*. Minnesota held its lead and went on to a 5–2 win behind Morris, who pitched seven strong innings.

Tapani faced Atlanta's ace left-hander, Tom Glavine, in the second game, and the Twins got off to a 2–0 lead on a two-run homer by Chili Davis in the bottom of the first. The Braves scored in the second and fifth, and the game remained tied going into the bottom of the eighth. On the first pitch of the inning, Scott Leius homered to left off Glavine. Aguilera put Atlanta down in the ninth, and Minnesota had a two-game lead in the series.

In Atlanta, the Braves won the next game in twelve innings and tied the series the following night, bringing in the winning run on a sacrifice fly by Jerry Willard in the last of the ninth. Three games in a row had been decided by one run, with the winning team scoring in its last at bat. Game Five wasn't close as the Braves beat the Twins 14–5, but back in Minnesota, the teams went back to tight games.

Facing elimination, the Twins took a 2–0 lead in the sixth game and kept the cushion in the third when Puckett leaped to rob Ron Gant of an extra-base hit with a runner on first. Atlanta tied the score on a two-run homer by Terry Pendleton in the fifth, but Puckett's sacrifice fly in the bottom of the inning put Minnesota ahead again. The Braves loaded the bases with one out in the seventh. Carl Willis relieved and got Gant to hit a grounder to short. The Twins got a force at second, but Gant, pumping his right fist as he crossed the base, beat the relay to first, allowing the tying run to score.

The game stayed tied into the last of the eleventh,

After many successful seasons with the Tigers, Jack Morris returned to his home state and helped the Twins win the World Series in 1991. *Minnesota Twins.*

when Charlie Leibrandt, who had started the first game of the series, entered in relief for the Braves. On his fourth pitch, Puckett homered to left center to win the game.

Puckett, the man with the big catch and big hit, had told his teammates before the game, "Jump on my back. I'll carry you!" When he did just that, his pre-game outburst appeared prophetic, although the popular Puckett had often said that. This time, he came through and sent the series to a seventh game.

Morris faced John Smoltz in the decisive game, and both pitchers dominated. Though the game stayed scoreless through nine, both teams threatened in the final innings. Lonnie Smith opened the eighth with a broken-bat single for Atlanta and then took off as Terry Pendleton hit a drive to left center. Smith didn't pick up the flight of the ball as it bounced

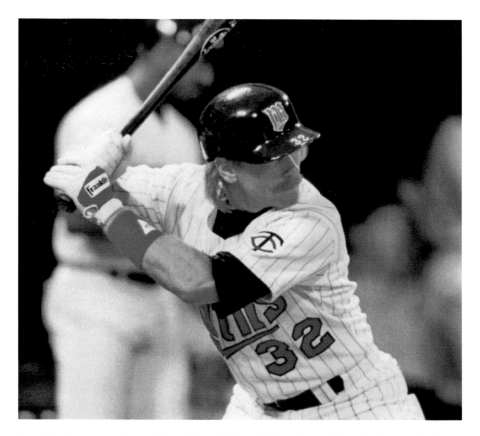

Dan Gladden played for the Twins from 1987 to 1991 and scored the winning run in the 1991 World Series. *Minnesota Twins*.

in the gap, delaying at second long enough that he wasn't able to score on the double. The Braves, with runners at second and third, still looked likely to break the shutout as the heart of the batting order was coming up. Morris was able to retire Gant on a weak grounder as the runners held. That allowed him to intentionally walk the dangerous David Justice to face the less dangerous Sid Bream. The strategy worked as Bream grounded to first. Hrbek threw home to force out Smith and then took the return throw at first to complete the double play and get out of the inning.

Minnesota loaded the bases in the last of the eighth with one out, but Hrbek lined out to second baseman Mark Lemke, who took the soft liner on the run and stepped on second to double off Knoblauch.

In the last of the ninth, the Twins got the first two runners on. Shane Mack grounded into a double play. With a runner then on third, pinch hitter Paul Sorrento struck out.

Morris was still on the mound for the Twins and retired the Braves in order in the tenth. Finally, the breakthrough came in the bottom of the inning as Dan Gladden, leading off, broke his bat on a ball that fell in safely in left field. Running hard all the way, Gladden made it to second with a double. Knoblauch sacrificed him to third, forcing the Braves to walk the next two hitters to load the bases.

With the infield at double play depth and the outfield playing in, since even a medium-deep fly would allow Gladden to tag up and score, pinch hitter Gene Larkin drilled a high fly to left center. Left fielder Brian Hunter gave chase, but the series would be over whether he caught it or not. Gladden held at third until he saw the ball drop beyond Hunter and then trotted home, where Morris and the rest of his teammates mobbed him.

One of the tightest, most dramatic World Series in history was over, and the Twins were champions again.

SLIDING INTO THE
NEXT CENTURY

J ack Morris stayed in Minnesota only one year, signing with the Toronto Blue Jays after the 1991 season. Some fans were angry that he left, although without him, they wouldn't have been celebrating another title. The Twins had lost Morris, but a few weeks before the 1992 season opened, they made a trade with Pittsburgh to get left-hander John Smiley, who had won twenty games for the Pirates the year before.

All appeared well for Minnesota in 1992, and the Twins opened up a first-place lead in June. Their main competitor was the Oakland Athletics, who had the "Bash Brothers" Jose Canseco and Mark McGwire leading the offense, as well as a strong pitching staff. Minnesota and Oakland were well matched, but the Twins were in control into late July.

Then came a series in Minnesota that transformed the season, and possibly the Twins' fortunes in the coming years. Oakland came to the Metrodome three games out of first. The Athletics won the first game and, in the second, came back from a four-run deficit to win 12–10. A win in the final game would put Oakland into a first-place tie with Minnesota.

The Twins had a 4–2 lead after eight innings in the finale. Rick Aguilera came in to close it out, but the Athletics got the first two runners aboard. Rickey Henderson flied out, but after a wild pitch put the runners at second and third, Eric Fox homered to right. Dennis Eckersley, who would end the season with fifty-one saves and receive the Cy Young and MVP Awards, retired the Twins in order in the last of the ninth, and Oakland and Minnesota were tied for first.

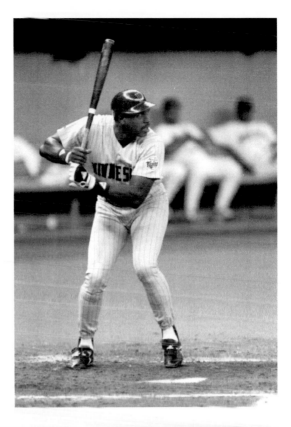

Right: Dave Winfield grew up in St. Paul and played for the Twins near the end of his career. *Minnesota Twins*.

Below: Like Dave Winfield, Paul Molitor is from St. Paul and got his 3,000th career hit while playing for the Twins. *Minnesota Twins*.

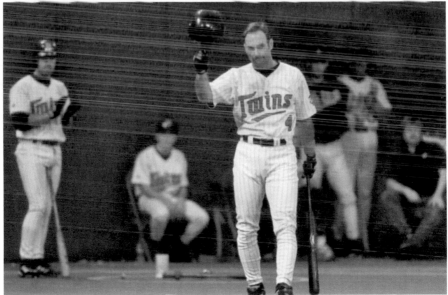

MILESTONES IN MINNESOTA

In addition to Dave Winfield, two other players, both on opposing teams, got their 3,000th hit in Minnesota. Eddie Murray of Cleveland acquired his on June 30, 1997, off Mike Trombley, while Cal Ripken of Baltimore got his on April 15, 2000, against Minnesota's Hector Carrasco. Also, two players hit their 500th career home run in Minnesota: Harmon Killebrew of the Twins on August 10, 1971, at Met Stadium and Frank Thomas of the Blue Jays on June 28, 2007, at the Metrodome.

Oakland went on to win the division, while the Twins went only 30-31 the rest of the way. The season got away from them with that series sweep by the Athletics, and the slide continued into the rest of the 1990s.

A notable acquisition in 1993 was Dave Winfield, who had grown up in St. Paul and been a star pitcher and hitter for the Minnesota Gophers in the 1970s. Winfield played a number of years with the San Diego Padres and New York Yankees. After two seasons with the Angels and one with the Blue Jays, he signed as a free agent with the Twins. Winfield's big moment of the season came on September 16, when he singled against Eckersley for his 3,000th career hit.

Winfield's hit was the highlight of the season for the Twins, who dropped to fifth place with a 71-91 record. The slide continued.

Minnesota finished fourth out of five teams in a strike-shortened 1994 season. (Starting in 1994, the leagues were split into three divisions; the Twins were in the Central Division, competing with four other teams, rather than six, for first place.) In 1995, the Twins dropped all the way to the bottom, forty-four games behind the first-place Cleveland Indians, a team that had become dominant after decades of dismal play.

The Twins had a new outfielder, Marty Cordova, who was named Rookie of the Year, but 1995 was also the last season for Kirby Puckett. He played during spring training in 1996 but had eye problems. Puckett was diagnosed with glaucoma, which ended his career.

Minnesota continued to struggle as the team combined young players with veterans. Paul Molitor signed with the Twins in December 1995. Like Winfield, Molitor was from St. Paul, signed as a free agent after many years with other teams, was eventually elected to the Hall of Fame and got his 3,000th hit in his first season with the Twins.

Another state native, Terry Steinbach from New Ulm, left the Oakland Athletics after eleven seasons and signed with the Twins for 1997. Also that season, right-hander Brad Radke had a breakout year, finishing with a won-loss record of 20-10.

Much of baseball news during this time was dominated by the Twins' quest for public funding for a new stadium. The Metrodome was only fifteen years old, but the troublesome nature of the escape clauses, which had remained in varying form, continually left the team with options for getting out of the lease. Owner Carl Pohlad envisioned a ballpark with a retractable roof being built along the Mississippi River, a few blocks from the Metrodome.

A 1997 proposal turned into a public relations disaster as what appeared to be the offer of a significant contribution by the Twins for a new stadium turned out to be more along the lines of a loan. In addition, the threat of a move by the Twins to North Carolina hung over the issue and turned off some fans. (In his 2000 book *Stadium Games: Fifty Years of Big League Greed and Bush League Boondoggles*, Jay Weiner claimed

Brad Radke won twenty games for Minnesota in 1997. *Minnesota Twins.*

Torii Hunter was a Gold Glove center fielder for the Twins. *Minnesota Twins.*

ALMOST OUTDOORS

Twins fans experienced twenty-eight seasons of indoor baseball between 1982 and 2009, but it appeared they might get a brief break from the dome in 2000. The team was in the midst of a decade-long quest for a new ballpark, and Chris Clouser, who had become the Twins' chief executive officer, thought that a few outdoor games might promote the process.

The Twins proposed moving a September series against Texas to a twenty-five-thousand-seat temporary ballpark in Bloomington, across the street from where they had played at Met Stadium for twenty-one years. A variety of hurdles beyond construction of such a facility faced the team, including issues with the Metrodome lease and getting permission from the Metropolitan Sports Facilities Commission, Major League Baseball, the players' association and the Texas Rangers.

Though the idea appealed to many people, the outdoor games didn't happen. The aborted venture remained the legacy of Clouser, who resigned from the Twins that December.

that a proposed ownership group in North Carolina was put in place more for the purpose of giving the Twins and Minnesota stadium proponents additional leverage than to present a serious offer to purchase and move the team.)

The 1997 stadium drive was derailed, although the campaign for a new ballpark continued.

The Twins were building for the future with players taken in the amateur draft. Torii Hunter, Matt Lawton, Jacque Jones, Doug Mientkiewicz, Corey Koskie, A.J. Pierzynski and Eddie Guardado were among the draft picks who debuted in the 1990s and stayed with the team as it got better.

Other youngsters came when the Twins traded Chuck Knoblauch to the Yankees after the 1997 season. Shortstop Cristian Guzman and left-hander Eric Milton were part of the return. Both players were a key part of the 2001 team that brought competitive baseball back to Minnesota, and Milton also pitched a no-hitter for the Twins in 1999.

Before the resurgence, however, were a few more lean years.

Minnesota ended up in the cellar in 1999 and 2000. Though they won six more games in 2000 than they had the year before, the Twins had the worst record in the

TWINS NO-HITTERS

Pitcher	Opponent	Date
Jack Kralick	Kansas City Athletics	August 26, 1962
Dean Chance*	Boston Red Sox	August 6, 1967
Dean Chance	Cleveland Indians	August 25, 1967
Scott Erickson	Milwaukee Brewers	April 27, 1994
Eric Milton	Anaheim Angels	September 11, 1999
Francisco Liriano	Chicago White Sox	May 3, 2011

Kralick took a perfect game into the ninth before walking pinch hitter George Alusik with one out.

*Chance pitched a five-inning perfect game against the Red Sox. The game was called because of rain in the last of the fifth.

Chance's no-hitter against Cleveland and Liriano's no-hitter against Chicago were on the road. The other no-hitters were at home.

The Twins have been no-hit five times: Jim "Catfish" Hunter of Oakland in 1968, Vida Blue of Oakland in 1970, Nolan Ryan of California in 1974, David Wells of the New York Yankees in 1998 and Jered Weaver of the Los Angeles Angels in 2012. The no-hitters by Hunter and Wells were perfect games.

NO-HITTERS BROKEN UP IN THE NINTH

Pitcher	Batter Breaking up No-Hitter
Al Schroll	Don Dillard of Cleveland with no outs on September 27, 1961
Gerry Arrigo	Mike Hershberger of the Chicago White Sox with no outs in the first game of a double-header on June 26, 1964
Dean Chance	Bill Voss of the Chicago White Sox with one out on June 1, 1968
Steve Luebber	Roy Howell of Texas with two out on August 7, 1976
Scott Baker	Mike Sweeney of Kansas City in the night game of a day-night double-header on August 31, 2007

Baker had a perfect game before walking John Buck leading off the ninth inning. One out later, he lost his no-hitter when Sweeney singled.

The Twins have broken up no-hit bids by opposing pitchers ten times. In 1969, Cesar Tovar twice victimized Baltimore pitchers (Dave McNally and Mike Cuellar). Joe Mauer broke up three no-hitters in the ninth inning between 2008 and 2013.

major leagues. What this meant was that the team would have the first selections in the 2001 amateur draft, which included top prospects.

Mark Teixeira, a switch-hitting infielder from Georgia Tech, and Mark Prior, a big right-hander from the University of Southern California, were among the college stars projected as top picks. A high school player, catcher Joe Mauer, was also rated highly. Mauer, a star in football, basketball and baseball at Cretin-Derham Hall High School in St. Paul, is considered the best athlete ever from Minnesota. He planned to play football at Florida State University, but it was likely that he could be lured directly into major-league baseball.

The choice for Minnesota came down to Prior and Mauer. As fans waited to see who the star of the future might be (it would be Mauer), the Twins opened the 2001 season with two wins in Detroit and one in Kansas City. After two losses to the Royals, Minnesota opened at home with a three-game sweep over Detroit.

The season was barely a week old, but the quick start generated excitement—and fans in the stands—for a series with the White Sox. After sweeping Chicago, the Twins were in first by four games.

The strong play continued. Radke won all five of his decisions in April. Mientkiewicz, a high school teammate of Alex Rodriguez in southern Florida, had been demoted to the minors in 2000. He hit well at the Triple-A level, as well as on the U.S. Olympic team as it won a gold medal, and got his job in the majors back in 2001.

Mientkiewicz was on fire the first seven weeks of the season. He had a batting average of .403 to go along with nine home runs and thirty-four RBIs through forty-three games. The Twins won thirty of those games and held first place.

Despite the hot starts by Mientkiewicz and Radke, it was three other players—shortstop Cristian Guzman and pitchers Joe Mays and Eric Milton—who were the Twins' representatives on the All-Star team.

OPENING AND CLOSING WITH A HOME RUN

In 2000, the Metrodome opened and closed with a home run. In the season opener, Gerald Williams of Tampa Bay hit the first pitch for a home run. In the last game of the year, Matt Lawton homered in the bottom of the tenth to give the Twins a 6–5 win over Chicago. Damion Easley of Detroit almost duplicated the opening-pitch home run in 2001. In the Twins' home opener, Easley drove Brad Radke's first pitch to deep center. Only Denny Hocking reaching up, with his glove above the fence, and catching it prevented a home run.

By the All Star break, the Twins were in first place, five games ahead of Cleveland, with a record of 55-32. The rest of the season didn't go as well. Guzman was hampered by a bad shoulder and out more than a month. By the time he returned to the lineup, Cleveland had taken control of the division.

Minnesota finished in second, six games behind the Indians. Even with the downturn in the second half, it was an encouraging season for the Twins. Beyond that, the strong Cleveland team was starting to break up. Juan Gonzalez left for free agency, and the Indians traded Roberto Alomar. It appeared time for another team to take over the Central Division.

CHAPTER 7

CENTRAL CHAMPS

Tom Kelly stepped aside as manager at the end of the 2001 season, and longtime coach Ron Gardenhire was named as his replacement.

Amid this news were reports that the major leagues were going to try and eliminate two teams. Reportedly, Carl Pohlad had offered the Twins to be contracted in exchange for a large sum of money, anywhere from $150 to $250 million. A court ruling in Hennepin County in early 2002 required the Twins to carry out their lease with the Metropolitan Sports Facilities Commission, ending a possibility of the Twins being contracted immediately. By the time the year was out, a new collective bargaining agreement eliminated the threat of baseball dropping any teams, at least through 2006. The Twins were safe in Minnesota, at least for the time being.

Even without the court's ruling, it's uncertain if any teams would have been contracted in 2002. However, the thought of the Twins on the chopping block made an irresistible story as the team took over the Central Division and headed to the playoffs. With Cleveland no longer a top team, the Twins had little competition. The Chicago White Sox, who two years earlier had won the division title, appeared to have a stronger roster. However, through the first ten years of the century, the White Sox often seemed to underachieve, and the decade belonged mostly to Minnesota.

THREE STRAIGHT TITLES

In 2002, Minnesota won ninety-four games and finished in first by thirteen and a half games over the White Sox. After splitting their first ten games of the season, the Twins got rolling, moved into first place and were never more than one game from the top the rest of the season. They took over first for good in late May.

Three players—Torii Hunter, Jacque Jones and David Ortiz—hit at least twenty home runs, and Hunter received his second of nine straight Gold Gloves for outstanding defense in the outfield.

A big night for the Twins came on September 6, when Brad Radke shut out Oakland on six hits, breaking the Athletics' 20-game winning streak. The A's won 103 games during the regular season and were the Twins' opening opponent in the playoffs.

Minnesota took the opening game in the best-of-five series, but Oakland won the next two. Facing elimination, the Twins fell behind 2–0 in the fourth game. However, a pair of runs in the third tied the game, and Minnesota broke it open with seven runs in the following inning to even the series.

In the decisive game, played in Oakland, the Twins built a small lead, padded it in the top of the ninth and then held off an Oakland rally in the bottom of the inning to win 5–4 and advance to the league playoffs.

The Anaheim Angels, who made the playoffs as a wild-card team, had knocked off the 103-win Yankees and came to Minnesota to start a best-of-seven series to determine who would be the American League representative in the World Series. Behind a strong outing from Joe Mays, the Twins won the first game, but the Angels took the next three games to come within a win of the pennant.

In the fifth game, the Twins scored three runs in the top of the seventh for a 5–3 lead. The Angels responded with a ten-run inning. Adam Kennedy hit a three-run homer, his third home run of the game, to put Anaheim ahead by a run, and the Angels kept rolling through the inning, the game and, eventually, the championship, beating the San Francisco Giants in the World Series.

Minnesota kept winning in the following years, but their 2002 performance was as close as they got to a pennant. In 2003, the Kansas City Royals were a surprise team, winning their first 9 games. At the other end of the Central Division, the Detroit Tigers lost their first 9 (on their way to losing 119 games, the most by a major-league team since 1962). In between were Minnesota, Chicago and Cleveland.

The Twins appeared to have overcome a poor opening month and were in first place for more than six weeks in May and June. A slump that followed dropped Minnesota to the middle of the pack, seven and a half games behind Kansas City at the All Star break.

During the break, the Twins traded Bobby Kielty to Toronto for left fielder Shannon Stewart, who had a quick impact. His acquisition and fine play coincided with a turnaround that put the Twins back in contention. Despite being with Minnesota only half the season, Stewart was named the team's most valuable player at the end of the year.

However, a bigger reason for the improvement may have been the starting pitchers, particularly left-hander Johan Santana, who got a regular spot in the rotation in mid-July. Santana had been an unprotected minor-league veteran, eligible to be drafted by other teams in the Rule 5 draft. Minnesota landed Santana after the 1999 season in a trade with the Florida Marlins. As is the case with other Rule 5 players, the Twins were simply looking for someone to fill a gap and improve the team, not become a star.

In his first years with Minnesota, Santana worked mainly out of the bullpen, first in a mop-up role and then in more important situations. He did well enough that the Twins were concerned about weakening their bullpen by making him a regular starter. Santana had a good fastball and curve, but he became known for his changeup. When he finally got his chance, Santana responded. He won all eight of his decisions in August and September as the Twins climbed in the Central.

Kansas City dropped back, but the White Sox hung in as the division became a two-team race. Minnesota and Chicago were at the top of the standings, separated by a half game as they began a three-game series at the Metrodome on September 16. Esteban Loaiza was going for his twentieth victory of the season in the opener, but the Twins knocked him out of the game in the third inning. Minnesota jumped out to another early lead the next night and won again. In the series finale, Jacque Jones hit a two-run homer in the last of the first to tie the game and another two-run shot in the third to put Minnesota ahead. The Twins held the lead in the game as well as the lead in the division for the rest of the season.

Minnesota went to New York to play the Yankees in the opening round of the playoffs. After taking the first game, the Twins lost the next three, ending their season.

The Twins decided that Joe Mauer was ready to play in the majors in 2004. Two weeks before his twenty-first birthday, Mauer made his debut in the opener with two hits and two walks. His second walk started a four-run,

game-tying rally in the eighth, and his second single was in the middle of an eleventh-inning rally that won the game for the Twins.

The following night, Mauer chased a pop foul toward the backstop in the third inning. Dropping to his knees at the warning track, he slid slightly on the surface. Mauer stayed in the game before being replaced by a pinch runner in the bottom of the inning as it became apparent he had hurt his knee. The injury, a medial meniscus tear in his left knee, put Mauer on the disabled list. He returned in June but was again shut down in mid-July.

Although he played in only thirty-five games his rookie season, Mauer had an impact on Minnesota in a different way. His arrival in the majors made catcher A.J. Pierzynski expendable, and the Twins traded him to San Francisco for pitchers Francisco Liriano, Boof Bonser and Joe Nathan. Nathan became the team's closer and had forty-four saves and an ERA of 1.62 in 72⅓ innings in 2004.

Justin Morneau, a power-hitting first baseman who had been up in 2003, took over the starting job from Doug Mientkiewicz in 2004. Morneau hit

Joe Mauer and Justin Morneau, flanking Hall of Fame catcher Johnny Bench, both won an MVP award. *Minnesota Twins.*

Johan Santana received the Cy Young Award in 2004 and 2006. *Minnesota Twins.*

nineteen home runs in seventy-four games. Unhappy about losing his spot, Mientkiewicz was traded to the Red Sox.

Johan Santana had his first full season as a starting pitcher. After a rocky start, he got hot in June. Beginning with a win over the New York Mets on June 9, Santana went the rest of the season by allowing no more than three runs in a game. He had an 18-2 record in his final twenty-two games and cut his ERA nearly in half. With a season record of 20-6 and a league-leading 2.61 ERA, as well as a league-high 265 strikeouts, Santana was the unanimous choice as the American League Cy Young Award recipient.

The Twins were never far from first place in 2004 and spent most of the season at the top of the standings, taking over first place for good in late July. Minnesota finished with ninety-two wins, nine games better than the second-place White Sox.

The Twins again faced New York in the first round of the playoffs. In the opener, Santana outdueled Yankees ace Mike Mussina in a 2–0 win. A win in the second game would bring the Twins back to Minnesota with a commanding lead in the series.

Game 2 was a wild one. Morneau's double in the first put the Twins in the lead. New York tied the score when Derek Jeter led off the bottom of the first with a home run off Brad Radke. The Twins got the lead back with two runs in the second, but Gary Sheffield's two-run homer in the third tied the game again. Alex Rodriguez put New York in front with a fifth-inning home run and later singled home a run to make the score 5–3.

Corey Koskie tied the game in the eighth with a bases-loaded double that scored two and put the go-ahead run at third with one out, but the Yankees got out of the inning without further damage, and the game went into extra innings.

With two out in the top of the twelfth, Torii Hunter homered, and it looked like the Twins might take the first two games on the road. However, Joe Nathan, in his second inning on the mound, walked two batters with one out in the bottom of the inning and faced the dangerous Rodriguez, who would be named the American League MVP in his first season with the Yankees. Rodriguez hit a ground-rule double to left-center to score the tying run; the winning run would have scored as well had the ball not bounced over the fence, but the reprieve for the Twins was brief. After an intentional walk to Sheffield, Hideki Matsui hit a sacrifice fly to bring in Jeter with the winning run.

Corey Koskie hit twenty-six home runs and drove in 103 runs in 2001, helping the Twins become competitive again. *Minnesota Twins.*

The series was tied as it moved to Minnesota, and the Yankees won the next game 8–4. Another win would send New York to the next round, but the Yankees first had to go against Johan Santana. If the Twins won, they would have Radke on the mound for the decisive game back in New York.

Santana was effective, holding the Yankees to one run, although he had to deliver a lot of pitches to do it and came out after five innings. The Twins built a 5–1 lead after seven and brought in Juan Rincón to protect it in the eighth. Rincón had been a reliable reliever during the season but got in trouble by giving up a single and walk to start the inning. Bernie Williams lined a single to score one run. Rincón fanned Jose Posada for the first out but couldn't get a third strike past Ruben Sierra, who fouled off a 2-2 pitch to stay alive and then hit a three-run homer to right-center to tie the game.

With one out in the top of the eleventh, Rodriguez doubled and stole third. With Sheffield at bat, Kyle Lohse bounced a pitch in the dirt that got by catcher Pat Borders, allowing Rodriguez to score. Mariano Rivera retired the Twins in order, and the season came to a screeching halt for Minnesota.

It was a disheartening loss for Minnesota, which had had trouble beating the Yankees in recent years and now had lost two straight playoffs to New York. However, Twins general manager Terry Ryan's program

of building a minor-league system and working young players in with veterans was proving to be effective. Fans had hopes for continued success and beyond—if the Twins could just beat those Yankees.

HOPE ON THE HORIZON

Joe Mauer recovered from his knee injury and was back in 2005, but he was one of the few players to do well offensively. The season belonged to Chicago. The White Sox were in first place from beginning to end and then won eleven of twelve games in the post-season to win the World Series for the first time since 1917. Minnesota hung with them for the first part of the season, but a stretch in June—in which the Twins lost two out of three games in five consecutive series while Chicago was on a roll—dropped them out of the race.

Better news was coming in off the field. Another push for a new stadium was producing results as the Twins and Hennepin County agreed on a package to fund a ballpark with an increase in the sales tax. Approval from the Minnesota legislature was needed for the county to raise its tax without a referendum. Facing more pressing issues, including a budget impasse that resulted in state government being shut down for more than a week in July, the lawmakers eventually adjourned without final action on a ballpark bill.

Finally, in 2006, the state legislation was approved, and that summer the Hennepin County Board of Commissioners authorized a .015 percent sales tax to partially fund a new ballpark on the northern edge of downtown Minneapolis, just over one mile to the northwest of the Metrodome and one block beyond Target Center, the arena that houses the Minnesota Timberwolves of the National Basketball Association. (Eventually, the naming rights for the Twins' stadium were sold to Target Corporation, which already held the rights to the name of the basketball arena, and the new ballpark would be Target Field.) The plan called for an open-air stadium with no provisions for a retractable roof. Money for a roof wasn't available, and the constraints on the eight-acre site would not allow for a movable roof to be added in the future even if money did become available.

Fans looked ahead to sunshine, rain and whatever else the new stadium would bring as they continued to follow the Twins indoors in what became a memorable race in 2006.

Though the Twins offense was about average on a league-wide basis, they had a number of players with big seasons. Mauer led the American

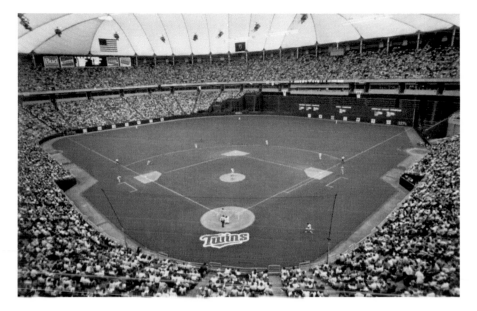

The Twins played in the Metrodome from 1982 to 2009. *Minnesota Twins.*

League with a .347 batting average, Michael Cuddyer had 109 RBIs and Morneau topped that with 130 RBIs to go with thirty-four home runs. For his performance, Morneau received the American League MVP award, edging out Derek Jeter of the Yankees and becoming the first Twins player to earn that honor since Rod Carew in 1977.

Johan Santana finished seventh in the MVP balloting and, for the second time in three years, was a unanimous pick for the Cy Young Award. Santana led the league in strikeouts for the third straight year, led the league with a 2.77 ERA and had a record of 19-6. As he had in previous years, he picked up steam as the season progressed.

Joining Santana as a staff ace was Liriano, who got his first start of the season in mid-May and was dominant. Unfortunately, the slider that was causing so much trouble for hitters was also putting a strain on Liriano's elbow. At the end of July, Liriano had his ERA down to 1.96, but he pitched only two more games and had Tommy John surgery (in which an elbow ligament is replaced with a tendon from elsewhere in the body), causing him to miss the rest of the 2006 season and all of 2007.

While Liriano was healthy, the Twins had a combination that was difficult to beat. From June 8 to July 8, Santana and Liriano had ten wins between them without a loss. The pair pitched 84⅔ innings with a combined ERA of

1.49 over that span. However, even with the hot pitching, the Twins made little ground on the division leaders during that time.

Minnesota was 25-33 on June 7, eleven and a half games behind first-place Detroit and eleven games behind second-place Chicago, which was the leader in the wild-card race. Although the Twins improved their record to 47-38 during the month when Liriano and Santana were in command, they were still eleven games behind the Tigers and eight back of the White Sox.

The Tigers, who had won only seventy-one games the year before and were only three years past their dismal 2003 season of 43-119, stayed strong. The White Sox, on the other hand, were struggling, and the race for the wild-card spot got tighter. By early September, the Twins had moved ahead of Chicago and were creeping up on Detroit as well.

It became apparent that both the Tigers and the Twins would make the playoffs; the question was which team would finish first and which would be the wild-card team. The teams were tied going into the last weekend of the season and remained tied on the final day. Minnesota, playing at home, beat Chicago. Fans stuck around and watched the rest of the Tigers game, which had gone into extra innings against the Royals, on the Metrodome's video screen. Kansas City scored two runs in the twelfth and won, setting off a rollicking celebration in the Metrodome.

The Twins had won the Central Division title, and the only time they had had first place to themselves was on the last day of the season. Getting the top spot rather than being the wild-card team meant Minnesota could open the playoffs at home and also avoid the Yankees in the first round.

However, it didn't matter. The Athletics came in and took two games in the Metrodome and then the finale in Oakland—another disappointing post-season conclusion for the Twins but one that came after an exciting and unpredictable year.

The 2007 season was the only one during the decade in which the Twins finished with more losses than wins. At 79-83, the record wasn't terrible, and the team didn't fall out of the race until late August. In addition, Twins fans were excited as work was beginning on a new ballpark.

Groundbreaking was scheduled for early August. However, about an hour before a game on August 1, bigger news occurred nearby. Only a few blocks from the Metrodome, the Interstate 35W bridge over the Mississippi River collapsed, killing thirteen people. With many fans already at the Metrodome, along with concerns about having them go home and create an even greater traffic snarl, the Twins played their game with the Royals while also announcing

POSTPONEMENTS—OUTDOORS AND INDOORS

The Twins played outdoors at Metropolitan Stadium from 1961 to 1981. In those twenty-one seasons, the Twins had eighty-eight games postponed, fourteen shortened by rain and five that ended as ties. Rain, along with poor field conditions, and cold were the usual reasons for games that weren't played to their natural conclusion, but other elements crept in. A 1961 game was stopped with the score tied after nine innings because of fog. The Twins' home opener in 1962 was pushed back after six inches of snow had fallen the night before. In 1976, the Twins made it through April but had a snow-out in May. Rain and a nearby tornado caused a June 1971 game to be called in the sixth inning.

The Twins and Boston were able to complete a game on August 25, 1970, but the players had to wait out a forty-three-minute delay in the fourth inning because of a bomb threat. Players and coaches

Fans mill on the field during a delay because of a bomb threat on August 25, 1970. *Minnesota Twins.*

gathered on the field, considered a safe spot from an explosion, while fans were directed to go to the parking lot. However, some fans made their way onto the field and mingled with the players during the delay, and a few vendors joined them, hawking their wares. (Another bomb threat came in during a game at the Met on September 25, 1976. This time the game wasn't halted, but fans were told of the threat and that they could stay at their own discretion.)

The 1978 and 1980 seasons produced the most postponements, seven each (with another game shortened by rain in 1980). The final season at the Met, 1981, was the only one without a postponement, although one game was shortened during a year in which the Twins played only sixty games at home because of a mid-season strike.

The move to the Metrodome meant games played as scheduled—usually. An April snowstorm in 1983 tied up Minneapolis and prevented the California Angels from getting to Minnesota, prompting a postponement (with the snow causing a collapse of the Metrodome roof later in the day).

The Twins played on August 1, 2007, an hour after the collapse of the Interstate 35W bridge a few blocks away, but the incident caused the Twins to postpone the next day's game.

A game in October 2004, tied after eleven innings, was suspended by a curfew imposed to allow for the conversion of the Metrodome for a Minnesota Gophers football game that night.

In addition to the postponements, a game in April 1986 was delayed because of a roof breach caused by heavy rain and wind. Two games—in August 1992 and May 2001—were delayed when some banks of lights in the Metrodome went out.

Note: The postponements noted do not count games that were rescheduled or cancelled because of strikes and lockouts in 1972, 1981, 1990, 1994 and 1995.

that the next day's game, along with groundbreaking ceremonies at the new site, would be postponed.

The groundbreaking took place at the end of the month, and construction progressed over the next two and a half years. The site for the ballpark had been a parking lot between two elevated roads: Fifth Street North to the northeast (beyond what would be the left-field stands) and Seventh Street North

to the southwest (behind first base). To the northeast, behind third base, is the Hennepin Energy Recovery Center, a waste-to-energy facility commonly known as the "garbage burner." Interstate 394 is to the southeast, beyond right field, and a plaza was built over the freeway ramps to connect the ballpark to downtown Minneapolis. Light rail lines were extended to the ballpark, which has an entrance for a commuter rail station.

FINAL YEARS IN THE METRODOME

Near the end of the 2007 season, Terry Ryan resigned as general manager. Bill Smith was promoted to take his spot and faced some decisions. Torii Hunter was in the last year of his contract with the Twins and, after the season, became a free agent and signed with the Angels.

The Twins still had another year of having Santana under contract, but they feared losing him to free agency. Instead, Minnesota traded Santana to the New York Mets for five players. The most prominent was Carlos Gomez. The speedy center fielder made a quick splash and deep impression on the fans in 2008.

Gomez had nine hits and four stolen bases in the first nine games of the season. He showed his speed in the outfield, covering ground in all directions. Five weeks into the season, Gomez led off a game in Chicago with a home run. He added a triple in the fifth, a double in the sixth and an infield single in the ninth to become the first Twins player to hit for the cycle since Kirby Puckett had done it in 1986. While the Twins waited to see if he could fill the spot vacated in center field by Hunter and prove to be an adequate return for Santana, "Go-Go" was making fans in Minnesota.

The pitching staff was balanced with the primary starters—Nick Blackburn, Scott Baker, Kevin Slowey, Glen Perkins and Livan Hernandez each producing between ten and twelve wins. Behind the plate, Mauer caught in 139 games and received his first of three straight Gold Gloves. He also led the league with a .328 batting average.

Minnesota and Chicago jockeyed for first place throughout the season. The Twins concluded their scheduled games with a 6–0 win over Kansas City at home, leaving them a half game ahead of the White Sox, who still had a game to make up. Chicago won that game, forcing a tiebreaker playoff with Minnesota.

Blackburn and John Danks battled through six scoreless innings before Jim Thome homered in the seventh for the only run of the game, giving the White Sox the division title.

The Twins started 2009 without Joe Mauer, who was out with back problems, but split their games in April. In Mauer's return, on May 1, he homered to left-center on his first swing of the season. He later walked and scored on a home run by Morneau to break a tie in the fifth, providing the Twins with the winning margin in the game.

Although Mauer was outstanding the entire season, the Twins struggled. They dropped to five games under .500 and to six and a half games behind first-place Detroit on August 20.

A few weeks later, Minnesota lost its second game of a series to Oakland and then got the news that Justin Morneau, who had thirty home runs and one hundred RBIs, would miss the rest of the season because of a stress fracture in his back.

The Twins were five and a half games out of first but won their next six games, including two against Detroit, to cut the gap to two games. During this stretch, Mauer and Michael Cuddyer carried the Twins, who won seventeen of their final twenty-one games, ending their scheduled games in a tie for first.

For the second straight year, the Twins played one game to decide the division title. Game 163, as it became known in Minnesota, was one of the most memorable in the history of the Metrodome.

In the top of the third, Magglio Ordonez put the Tigers ahead with a run-scoring single, bringing up Miguel Cabrera, who followed with a long home run to right-center for a 3–0 Detroit lead.

The Twins scored an unearned run on an errant pickoff throw in bottom of the third and got within a run on a two-out home run by Jason Kubel in the sixth. With one out in the last of the seventh and Nick Punto on first, Orlando Cabrera homered to left to put the Twins ahead 4–3. However, Ordonez led off the eighth with a home run to tie the game.

From here the game took on elements of the seventh game of the 1991 World Series, the drama building as the teams threatened to score and, more often than not, didn't. After Ordonez's homer, the Tigers got back-to-back walks with one out, but Joe Nathan relieved and got out of the inning.

Detroit put runners on first and third with no out in the top of the ninth, but Nathan struck out Placido Polanco. Ordonez then hit a liner to short. Orlando Cabrera caught it and threw to first to double off Curtis Granderson and end the inning. Punto worked a ten-pitch walk to start the bottom of the inning and was sacrificed to second but was stranded there.

The Tigers broke through in the tenth on Brandon Inge's two-out double that scored Don Kelly from first. Cuddyer opened the last of the tenth with a

soft fly to left. Ryan Raburn tried for and missed a diving catch, and the ball bounced by him, allowing Cuddyer to reach third with a triple. One out later, Matt Tolbert hit a chopper up the middle for a single that scored Cuddyer with the tying run and sent Alexi Casilla (a pinch runner for Brendan Harris, who had been intentionally walked) to third. Detroit had the infield and outfield in when Punto hit a soft liner to left. Raburn was able to go to his left, catch the fly and then throw home to get Casilla, who had tagged and was trying to score the winning run.

Detroit mounted another threat in the twelfth, loading the bases with one out. Ron Mahay's first pitch to Inge was inside and appeared to brush his uniform, which would have forced in the go-ahead run. However, plate umpire Randy Marsh ruled that he had not been hit by the pitch. Inge then hit a grounder to Punto, who pivoted and threw home for a force out. Gerald Laird swung at and missed a 3-2 pitch that was out of the strike zone, getting the Twins out of the inning.

Gomez grounded a single to left to lead off the bottom of the twelfth and went to second when Cuddyer broke his bat and grounded out to third. On a 1-1 pitch, Casilla grounded a single through the hole to right. Clete Thomas, playing toward right-center, had to go to his left to field the ball and heaved it home, but Gomez easily scored the winning run.

The Twins, having won the American League Central Division, ran a victory lap around the Metrodome, engaging in a celebration with the fans that could be enjoyed only briefly because the team had to head to New York to start the playoffs the following night.

The Yankees won the first game of the series, but the Twins had their chances in the second game and broke a tie with a two-run rally in the eighth. In the last of the ninth, though, Alex Rodriguez hit a two-run homer to center off Nathan to send the game into extra innings.

In the eleventh, Mauer dropped a fly down the left-field line that hit in fair territory and bounced in the seats for what should have been a double. However, Phil Cuzzi called the ball foul. Mauer still got on base by singling to center and reached third with no outs after singles by Kubel and Cuddyer. Delmon Young then lined out to Mark Teixeira at first, and Gomez grounded to Teixeira, who threw home to force Mauer. Harris flied out to end the inning, leaving the game tied.

The Yankees quickly ended it as Teixeira lined a homer to left leading off the last of the eleventh.

The series came to Minnesota for the third possible final game at the Metrodome. The first had been the final scheduled regular-season game.

Had the Twins lost that, their season would have ended. The second was the tiebreaker game against Detroit, which the Twins won to keep going. Now Minnesota faced another elimination game that could end their season and the history of major-league baseball in the Metrodome.

Carl Pavano of the Twins and Andy Pettitte of the Yankees allowed few runners through the first five innings. In the last of the sixth, the Twins got to Pettitte as Mauer singled home Denard Span with two out for a 1–0 lead.

With one out in the top of the seventh, Rodriguez homered to right to tie the game, and one out later, Jorge Posada homered to left to give the Yankees a 2–1 lead. Minnesota's chance to tie in the last of the eighth was expunged on a baserunning blunder by Punto, who had led off the inning with a double. Span hit a chopper up the middle for a single, but Derek Jeter was able to snare the ball before it got into center field. Punto, not realizing that the ball hadn't gotten through, was running hard around third when he saw coach Scott Ullger's stop sign. Punto slid to a stop as Jeter's throw came home and then tried to get back to third but was nailed by Posada's relay to Rodriguez. After Orlando Cabrera flied out, Mariano Rivera came in and got Mauer to break his bat and ground out to first to finish the inning.

New York padded the lead with two runs in the ninth, and Rivera finished it off in the last of the ninth, extending the Twins' frustration against the Yankees and ending the team's twenty-eight-year run in the Metrodome.

Mauer was rewarded for his big season with the MVP award and received another Gold Glove at catcher. He was the American League's top offensive player, hitting twenty-eight home runs, scoring ninety-four runs and driving in ninety-six while leading the league with a .365 batting average, .444 on-base percentage and .587 slugging average.

The timing was good for the twenty-six-year-old star, as Mauer had only one year remaining on his contract. If the Twins couldn't sign him to a contract extension, they would risk losing him as a free agent after the 2010 season. Pressure was on the Minnesota organization to not allow the hometown savoir to go the route of Torii Hunter and Johan Santana.

Rather than having Mauer's status put a damper on the upcoming season in a new ballpark, the Twins extended his contract for another eight seasons for a total of $184 million. Fans were happy, and Minnesotans looked forward to the opening of Target Field.

CHAPTER 8

OUTDOORS AGAIN

Target Field boasts many features and amenities, including a range of dining options, that had not been present in the Twins' previous homes. In addition, the Twins used the high-profile nature of their new ballpark to highlight issues of sustainability. The ballpark includes a membrane filtration system to capture and treat rainwater for use in irrigating the field and washing the grandstand. In addition to reducing municipal water usage by more than 50 percent, saving more than 2 million gallons of water each year, the arrangement brings attention to the global issue of water, raising awareness of the value of sustainability and the wise use of water.

The first event in Target Field was a college baseball game between the Minnesota Gophers and Louisiana Tech Bulldogs on Saturday, March 27, 2010. Clint Ewing of the Bulldogs hit the first home run in the park as Louisiana Tech beat Minnesota 9–1. Approximately thirty-five thousand people passed through on the first day, with fans watching the game while also checking out the features of the new digs.

The following weekend, the Twins hosted a pair of exhibition games, both in front of sellout crowds, against the St. Louis Cardinals. Denard Span of Minnesota hit the first major-league home run in Target Field during a win by the Cardinals on Friday, April 2.

The Twins went on the road to open the regular season and returned for a home stand, starting against the Boston Red Sox, on Monday, April 12. Under partly cloudy skies with a temperature of sixty-five degrees, Minnesota's Carl Pavano delivered the first pitch at 3:13 p.m., officially

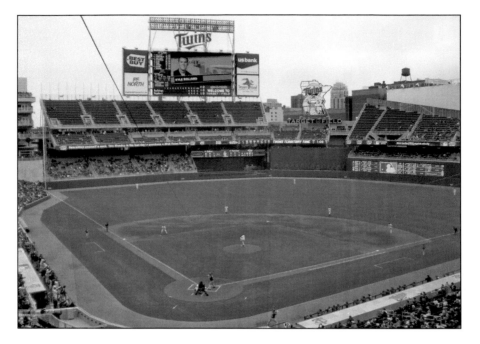

T.J. Oakes of the Minnesota Gophers delivers the first pitch in the history of Target Field to Kyle Roliard of Louisiana Tech on March 27, 2010. *Photo by the author.*

bringing outdoor major-league baseball back to Minnesota. The Twins won the game 5–2, with Jason Kubel of Minnesota hitting the only home run, a drive to right leading off the last of the seventh. Two innings earlier, Boston's Mike Cameron had hit a long fly to left that disappeared in a narrow gap between the foul pole and a limestone wall. Third-base umpire Kerwin Danley ruled the ball foul, but the umpires conferred and decided to use video replay (a process adopted by Major League Baseball in 2008 to rule on home runs and potential home runs) to confirm or overturn the call. Danley's foul ruling was upheld, and Cameron struck out on the next pitch. Video replay became a relatively common occurrence at Target Field during its first year; it was used eight times (with two calls being overturned and six upheld) in 2010, setting a record for the most uses of replay in a season at one stadium.

In its first season, Target Field demonstrated itself to be a pitchers' park as it was below average in runs scored and last in home runs. Joe Mauer, after hitting 28 home runs in 2009 (16 in the Metrodome), hit only 9 in 2010, 2 of them at home. On the other hand, Jim Thome, signed by the Twins as a free agent before the season, hit 15 of his team-high 25 home runs at Target

Field in 2010, including a Labor Day blast off the top of the flag pole in right that was measured at 480 feet. He climbed to 589 career home runs, passing Rafael Palmeiro, Harmon Killebrew, Mark McGwire and Frank Robinson for eighth place on the all-time list.

Target Field—its center-field entrance only a block from what had been the left-field corner of Athletic Park, which was the home of the Minneapolis Millers from 1889 to 1896—was a popular destination for fans its first season. Out of eighty-five games (including two exhibition and two playoff games), all but two were sold out, and the Twins had a regular-season attendance of 3,223,640.

The play on the field matched the excitement of the new ballpark. Minnesota spent much of the season in first place and took the lead for good in August. With a record of 94-68, the Twins finished six games ahead of the second-place White Sox and even got home-field advantage in the first round of the playoffs.

However, a familiar opponent, the Yankees, produced a familiar outcome. New York won both games at Target Field and the next one at Yankee Stadium.

Despite Target Field's tendency to favor pitchers, a number of Twins did well offensively. Even though his homer total dropped, Mauer had a batting average of .327 and an on-base percentage of .402. Michael Cuddyer did well, as did Jason Kubel, Jim Thome and Delmon Young, who hit twenty-one home runs and drove in 112 runs.

Justin Morneau hit only four homers at Target Field, but he had eighteen total in early July. On July 7 in Toronto, Morneau slid into second to break up a double play. His head collided with second baseman John McDonald's knee, and Morneau came out of the game. He suffered a concussion and didn't play again that season. At the time of the injury, Morneau had an on-base percentage of .437 and a slugging average of .618. He returned in 2011 but was never the same hitter or player again. After a few years of greatly reduced performance, Morneau was traded to Pittsburgh near the end of the 2013 season.

Mauer also had injury problems in 2011 and played in barely half of Minnesota's games. An acquisition from Japan, Tsuyoshi Nishioka didn't play as well as had been hoped at the plate or in the field at second base and shortstop. Among the hitters, only two stood out—Cuddyer and Thome, the latter in a platoon role before being traded to Cleveland in August shortly after hitting his 600th career home run.

Minnesota scored the fewest runs in the league, and their pitchers gave up the second-most. Not one of the hurlers won ten games, and only a shutout

by Carl Pavano in the final game of the year kept the Twins from losing one hundred games for the second time in their history. Minnesota's record of 63-99 was the worst in the American League.

The Twins improved a bit with the bats in 2012, helped by the free-agent signing of Josh Willingham, who hit thirty-five home runs, but they gave up the second-highest number of runs again and again ended the year with the worst record in the league.

Minnesota looked ahead when young players in their farm system would be ready for the majors and tried to put together a respectable team in the meantime. With the second overall pick in the 2012 amateur draft, the Twins selected outfielder Byron Buxton, who became one of the top prospects in baseball. They had already signed Miguel Sano, a power-hitting infielder from the Dominican Republic. Sano had been one of the subjects of the documentary *Ballplayer: Pelotero*, which followed Sano and another player through the process of being scouted and signed by major-league teams.

While the Twins waited for these and other prospects to develop, they made some trades for other youngsters as well as a few players to try to improve. The minor-league system was bolstered, although the 2013 Twins didn't improve. Their hitters set a new standard in futility, breaking the team

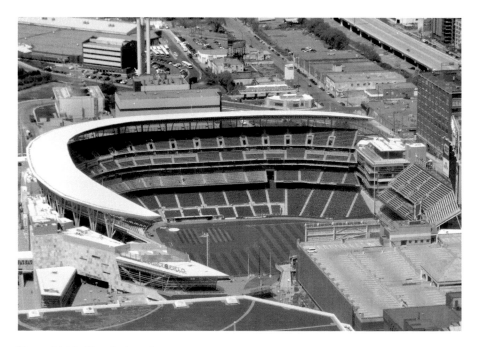

Target Field. *Photo by the author.*

record for strikeouts in a season with still over a month to play. For the second time in three years, Minnesota had no pitchers with double figures in wins. They had a record of 66-96, the same as the year before, but they avoided the cellar, as the Chicago White Sox were even worse.

Joe Mauer once again reached base safely more than 40 percent of the time, in line with his career on-base percentage, but his season was cut short by a concussion after taking a foul ball off his mask in August. During the off-season, the Twins announced Mauer would be moving to first base in hopes of cutting down on the risk of injury at catcher and keeping his valuable bat in the lineup.

During the 2012–13 off-season, the Twins hit the free-agent market in a big way, signing pitchers Ricky Nolasco and Phil Hughes as well as catcher Kurt Suzuki and former Twins outfielder Jason Kubel. In addition to these signings, Twins fans were able to look forward to the 2014 All Star Game in Minnesota.

Up and down for more than a half century in Minnesota, the Twins have provided the Upper Midwest with major-league baseball, the chance to see the best players in the game and the thrill of witnessing two world championships.

Twins Leaders
and Honors

Most Valuable Player

Zoilo Versalles, 1965
Harmon Killebrew, 1969
Rod Carew, 1977
Justin Morneau, 2006
Joe Mauer, 2009

Cy Young Award

Jim Perry, 1970
Frank Viola, 1988
Johan Santana, 2004
Johan Santana, 2006

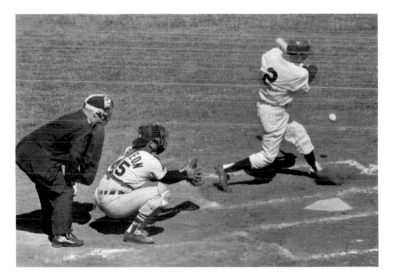

Zoilo Versalles. *Minnesota Twins.*

Rookie of the Year

Tony Oliva, 1964
Rod Carew, 1967
John Castino, 1979 (tie)
Chuck Knoblauch, 1991
Marty Cordova, 1995

Twins in the Baseball Hall of Fame

Bert Blyleven
Steve Carlton
Rod Carew
Harmon Killebrew
Paul Molitor
Kirby Puckett
Dave Winfield

LEAGUE LEADERSHIP

Batting

Home Runs

1962—Harmon Killebrew, 48
1964—Harmon Killebrew, 49
1967—Harmon Killebrew, 44 (tie)
1969—Harmon Killebrew, 49

Runs Batted In

1962—Harmon Killebrew, 126
1969—Harmon Killebrew, 119
1977—Larry Hisle, 119
1994—Kirby Puckett, 112

Slugging Average

1963—Harmon Killebrew, .555
1971—Tony Oliva, .546
2009—Joe Mauer, .587

Batting Average

1964—Tony Oliva, .323
1965—Tony Oliva, .321
1969—Rod Carew, .332
1971—Tony Oliva, .337
1972—Rod Carew, .318
1973—Rod Carew, .350
1974—Rod Carew, .364
1975—Rod Carew, .359
1977—Rod Carew, .333
1989—Kirby Puckett, .339
2006—Joe Mauer, .347
2008—Joe Mauer, .328
2009—Joe Mauer, .365

Runs

1963—Bob Allison, 99
1964—Tony Oliva, 109
1965—Zoilo Versalles, 126
1977—Rod Carew, 128

Total Bases

1964—Tony Oliva, 374
1965—Zoilo Versalles, 308
1988—Kirby Puckett, 358
1992—Kirby Puckett, 313

Walks

1966—Harmon Killebrew, 103
1967—Harmon Killebrew, 131
1969—Harmon Killebrew, 145
1971—Harmon Killebrew, 114

Hits

1964—Tony Oliva, 217
1965—Tony Oliva, 185
1966—Tony Oliva, 191

1969—Tony Oliva, 197
1970—Tony Oliva, 204
1971—Cesar Tovar, 204
1973—Rod Carew, 203
1974—Rod Carew, 218
1977—Rod Carew, 239
1987—Kirby Puckett, 207 (tie)
1988—Kirby Puckett, 234
1989—Kirby Puckett, 215
1992—Kirby Puckett, 210
1996—Paul Molitor, 225

Pitching

Earned Run Average (ERA)

1988—Allan Anderson, 2.45
2004—Johan Santana, 2.61
2006—Johan Santana, 2.77

Wins

1965—Jim "Mudcat" Grant, 21
1966—Jim Kaat, 25
1970—Jim Perry, 24 (three-way tie)
1977—Dave Goltz, 20 (three-way tie)
1988—Frank Viola, 24
1991—Scott Erickson, 20 (tie)
2006—Johan Santana, 19 (tie)

Innings Pitched

1966—Jim Kaat, 304⅔
1967—Dean Chance, 283⅔
1985—Bert Blyleven, 293⅔
 (with Cleveland and Minnesota)
1986—Bert Blyleven, 271⅔
2006—Johan Santana, 233⅔

Complete Games

1962—Camilo Pascual, 18
1963—Camilo Pascual, 18 (tie)
1966—Jim Kaat, 19
1967—Dean Chance, 18
1985—Bert Blyleven, 24
 (with Cleveland and Minnesota)
2010—Carl Pavano, 7 (tie)

Shutouts

1961—Camilo Pascual, 8 (tie)
1962—Jim Kaat and Camilo
Pascual, 5 (three-way tie)
1965—Jim "Mudcat" Grant, 6
1973—Bert Blyleven, 9
1985—Bert Blyleven, 5 (with
Cleveland and Minnesota)
1996—Rich Robertson, 3 (three-
 way tie)
2008—Kevin Slowey, 2 (eight-
 way tie)
2010—Carl Pavano, 2 (tie)

Strikeouts

1961—Camilo Pascual, 221
1962—Camilo Pascual, 206
1963—Camilo Pascual, 202
1985—Bert Blyleven, 206
 (with Cleveland and Minnesota)
2004—Johan Santana, 265
2005—Johan Santana, 238
2006—Johan Santana, 245

Saves

1969—Ron Perranoski, 31
1970—Ron Perranoski, 34
1979—Mike Marshall, 32
2002—Eddie Guardado, 45

SOURCES

BOOKS AND ARTICLES

Armour, Mark L., and Daniel R. Levitt. *Paths to Glory: How Great Baseball Teams Got That Way*. Washington, D.C.: Brassey's Inc., 2003.

Bingham, Walter. "Not Such a Tough Cookie." *Sports Illustrated*, May 15, 1961.

Bjarkman, Peter C. "Washington Senators-Minnesota Twins: Expansion-Era Baseball Comes to the American League." In *Encyclopedia of Major League Baseball Team Histories: American League*. Westport, CT: Meckler media, 1991.

Carew, Rod, with Ira Berkow. *Carew*. New York: Simon and Schuster, 1979.

Devaney, John. "How Mudcat Changed His Acts." *Sport*, September 1965.

Furlong, Bill. "The Feuding Twins: Inside a Team in Turmoil." *Sport*, April 1968.

Klobuchar, Amy. *Uncovering the Dome: Was the Public Interest Served in Minnesota's 10-Year Political Brawl over the Metrodome?* Minneapolis, MN: Bolger Publications Inc., 1982.

Larson, Don W. *Land of the Giants: A History of Minnesota Business*. Minneapolis, MN: Dorn Books, 1979.

"Minneapolis: Big-League Town in Waiting," *Sport*, December 1959.

Nichols, Max. "The Kaat Organization," *Sport*, December 1966.

The Sporting News. *Official Baseball Guide*, 1961–2005.

Weiner, Jay. *Stadium Games: Fifty Years of Big League Greed and Bush League Boondoggles*. Minneapolis: University of Minnesota Press, 2000.

Zanger, Jack. "And One Vote for Cesar." *Sport*, June 1968.

NEWSPAPERS

Minneapolis Star
Minneapolis Star and Tribune
Minneapolis Tribune
New York Times
Sporting News
St. Louis Park Dispatch
Washington Post

OTHER

Armour, Mark. "Joe Cronin." Society for American Baseball Research BioProject. http://sabr.org/bioproj/person/572b61e8.

Cavanaugh, Laurie L. "What Makes a Market Great for Major League Baseball: A Brief Presentation of the Advantages of the Twin Cities as the Location for a Major League Baseball Franchise, Seated at Metropolitan Sports Stadium, Minneapolis." *Minneapolis Star Tribune*, September 1957.

O'Malley, Walter. "File Memorandum re Giants, Los Angeles, etc.," March 23, 1957. http://www.walteromalley.com.

Quirk, James. "Stadiums and Major League Sports: The Twin Cities." Brookings Institute, 1997.

ABOUT THE AUTHOR

Sports historian Stew Thornley has written more than forty books for adults and young readers. His first book, *On to Nicollet: The Glory and Fame of the Minneapolis Millers,* was a finalist in the 1988 Minnesota Book Awards and earned him a national research award sponsored by the Society for American Baseball Research (SABR) and Macmillan Publishing Company. A member of SABR since 1979, Thornley has served as the organization's vice-president. Thornley is an official scorer for Minnesota Twins home games for Major League Baseball and for the Minnesota Timberwolves for the National Basketball Association.

Photo by Kyle Traynor.